Korean Court Dance

As Seen in Historical Documents

Lee Heung-gu Lee Heung-gu, title holder of Important Intangible Cultural Property No. 40, the Crane and Lotus Dance (Hak-yeonhwadaemu), was born in 1940 in Daecheon, Chungcheongnam-do Province. From 1955 to 1961 he studied dance at Gugaksa Yangseongso, an academy for training in the traditional performing arts, where his teachers included Kim Bo-nam, title holder of Important Intangible Cultural Property No. 1, Jongmyo Jeryeak, and Kim Cheon-heung, title holder of Important Intangible Cultural Property No. 39, the Dance of Cheoyong (Cheoyongmu). Lee served as director of the Korean Folk Arts Academy, standing dance and artistic director of the dance troupe at the National Center for Korean Traditional Performing Arts, advisor to the Korean Cultural Heritage Foundation, and professor of traditional dance at the Korea National University of the Arts. Currently, he is chairman of the board of the Daeakhoe Foundation, and chairman of the Foundation for the Preservation of the Crane and Lotus Dance, and is active in efforts to preserve and pass on traditional Korean dance. Twice annually from 1980 to 1999 he performed concerts reviving traditional dances in their original form and between 1987 and 1999 he published nine volumes in an ongoing series on traditional Korean court dance. In 2006, Lee was awarded the Bogwan Order of Cultural Merit.

Cho Yoon-jung Cho Yoon-jung grew up in Australia where she studied architecture at New South Wales University and received a Master of Applied Linguistics from Sydney University. She is a part-time lecturer at Ewha Womans University Graduate School of Translation and Interpretation.

Korean Court Dance
As Seen in Historical Documents
by Lee Heung-gu

Published by the Korea Foundation

Translator: Cho Yoon-jung
Copy Editor: Judy Van Zile
Book Design & Layout: Culture Books

The Korea Foundation
Seocho P.O. Box 227
Diplomatic Center Building, 2558 Nambusunhwanno
Seoul 137-863, Korea
Tel: (82-2) 2151-6542
Fax: (82-2) 2151-6592
Email: publication@kf.or.kr

Printed in Korea

ISBN 978-89-86090-37-6 04600
 978-89-86090-27-7 (SET)

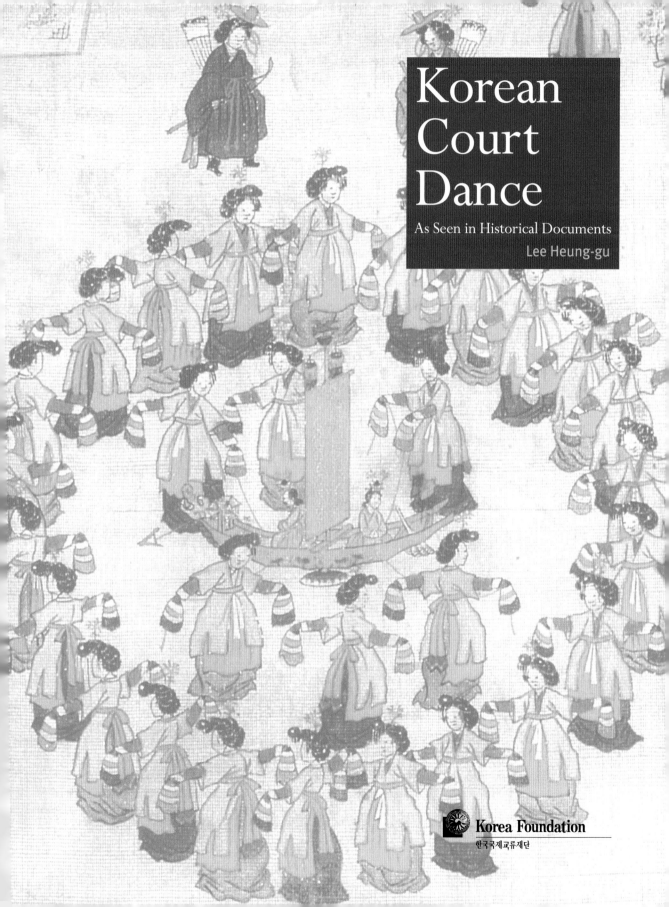

Korean
Court
Dance

As Seen in Historical Documents

Lee Heung-gu

Korea Foundation
한국국제교류재단

CONTENTS

I.
INTRODUCTION

Korean court dance is a precious cultural asset that has been handed down over a long period of time. From the Three Kingdoms period (37 BCE-668 CE) through the Goryeo (918-1392) and Joseon (1392-1910) dynasties, it changed according to changes in the political, moral and cultural climate of each era.

Because of its proximity to China, throughout history Korea had significant exchanges not only with China but also with regions west of China, particularly India, and all kinds of dance and musical instruments were introduced from those countries from the Three Kingdoms period. Evidence of this can be found in the tomb murals of Anak from the Goguryeo Kingdom, Silla relics and historical sites, and old books and documents from both Korea and China.

During the following Goryeo Dynasty, a large number of dances and musical compositions were introduced from Song Dynasty China. These dances were not reproduced intact but were adapted, or localized, for Korean purposes, omitting elements that were not in line with Korean sentiment. Court dance reached a height during the Joseon Dynasty, with 30 of the 45 court dances known from various documents dating to that time. Dances which had been changed from the Chinese originals were recreated to reflect Joseon's policy of suppression of Buddhism and promotion of Confucianism. As a result, dance movements and formations came to be based on the yin-yang theory and the five elements. The Korean court dances that have survived to the present are products of such historical change and expressions of the traditions and tastes of the Korean people.

As a dance form that thus developed and flourished over a great period of time under the supervision of the state, court dance was performed as entertainment at national celebrations, court banquets, banquets for foreign envoys, and banquets for members of the royal family.

The Korean term for court dance is *jeongjae*, which literally means

to "offer up one's talent and abilities to the king." Hence, the word originally referred not only to dance but to all kinds of skills including acrobatics and tightrope walking. Over time, however, it became a synonym for court dance and now refers to the music and dance that was presented at court ceremonies. Therefore, *jeongjae* can be defined as all music and dance that was presented to the king and high officials at the court.

Court dance can be divided largely into two categories: *dangak jeongjae*, which refers to court dance introduced during the Goryeo Dynasty from the Song Dynasty of China, and *hyangak jeongjae*, which refers to native Korean court dance. The categorization, however, can be a little misleading since *dangak jeongjae* includes not only those dances directly imported from China but also those created in Korea in the Chinese style. For the sake of convenience, dances are categorized as Chinese or Korean in origin depending on the presence or absence of three elements in the dance: pole bearers (*jukganja*), an opening refrain (*guho*), and a song praising the king (*chisa/chieo*). Dances containing all three elements are categorized as dangak *jeongjae*. The pole bearers lead the dancers on and off the stage and the songs, which generally laud the king, hail his achievements and express wishes for the prosperity of the court, are sung in the original Chinese character versions. In native Korean court dance, the dancers bow when they enter the stage and once again before leaving the stage, and the songs are sung in native Korean. Another point of difference is that the dancers do not hold ceremonial implements such as fans and parasols as they do in *dangak jeongjae*.

The category of *dangak jeongjae*, however, includes dances created in Korea but that are Chinese in style, such as Monggeumcheok, Suborok, Geuncheonjeong, Sumyeongmyeong, Hahwangmyeong, Seongtaek, Yeonbaekbokjimu, Jangsaengboyeonjimu, Jesuchang, and Choehwamu. Dances specifically imported from China include Heonseondo,

Suyeonjang, Oyangseon, Pogurak, Yeonhwadae, Yukhwadae, and Gokpa.

Even dances imported from China, however, can be understood as Korean court dance in that they were adapted to Korean culture and have been performed in Korea for many centuries to native music, using native dance movements, and in native Korean costume.

Hence, both categories of court dance, *dangak jeongjae* and *hyangak jeongjae*, are considered to be traditional Korean performing arts and relics of Korean society of the past, holding great value for preservation and transmission.

Today court dance is performed at the National Center for Korean Traditional Performing Arts and other small theaters for entertainment purposes, but largely in the context of preservation. Dances considered worthy of systematic preservation efforts are designated by the central government as Intangible Cultural Properties, each managed by one dancer who is the title holder, or Living Cultural Treasure. The title holder trains younger dancers in the art, and one of these trainees is usually designated as the next title holder. Only three court dances have been given Intangible Cultural Property designation so far: Cheoyongmu, Hak-yeonhwadaemu, and Jongmyo Jeryeak. There is a separate association overseeing the preservation of each of these dances.

This book examines the original form of Korean court dances based on a study of historical documents including *Musical Canon of Joseon (Akhak Gwebom)*, a monograph on music titled *Akji* from *History of Goryeo (Goryeosa)*, *History of the Three Kingdoms (Samguk sagi)*, *Expanded Reference Compilation of Korean Documents (Jeungbo munheon bigo)*, and *Study of Traditional Korean Dance (Hanguk jeontong muyong yeongu)*. The two most important primary sources are the *uigwe*, a collection of royal protocols recording in text and illustrations the exact procedures for banquets and rites held at the royal palace, and an illustrated record of the movements of Joseon Dynasty court dance titled *Jeongjae mudo holgi*.

1. Documentary References to Court Dance

Mentions of court dance can be found in various historical documents. According to the chapter "Royal Chronicles" in the *History of Goryeo (Goryeosa)*, in 943 the king left a document containing his last wishes, which was to be handed down to his descendants.

> My wishes are for Yeondeunghoe and Palgwanhoe. Yeongdeunghoe is held to serve the Buddha and Palgwanhoe is held to serve the god of heaven, the five famous mountains, major mountains and large rivers, and the Dragon God. After I am gone, prohibit any iniquitous persons from meddling with these events.

This statement is important because the two festivals mentioned were Buddhist events at which dances were performed. Buddhism was first introduced to the Goguryeo Kingdom in 372 during the reign of King Sosurim, and to Silla in 527 during the reign of King Beopheung. After the transmission of Buddhism from Goguryeo to Silla the Yeondeunghoe and Palgwanhoe festivals developed into nationwide events.

Yeondeunghoe, a Buddhist festival commonly called the Lotus Lantern Festival, was held on Buddha's birthday in the fourth lunar month. The festival began on the full moon day (15th) of the second month when the king went to offer incense at Bongeunsa Temple (in today's Samseong-dong, Seoul). It was a day of celebration where the king and his retainers joined the people in a festival of song, dance and drinking, and prayed for the favor of the Buddha.

Palgwanhoe, or the Festival of the Eight Vows, was held on the full moon day of the 11th lunar month, when the king proceeded to Beopwangsa Temple in Gaegyeong for a rite of obeisance before the Buddha. It was held in other locations (in Seogyeong and Pyongyang)

in the 10th lunar month every year.

The Palgwanhoe festivities featured many kinds of dance, including the rituals of the Samhan period (c. 108-57 BCE), the dances of Silla's elite warriors called *hwarang*, and ritual dance. The Samhan rituals were mainly rites to heaven (called Yeonggo, Mucheon and Dongmaeng). The *hwarang* dances include Saseonmu (Dance of the Four Immortals); Seonyurak, a boating dance; Pogurak, a ball throwing dance; Gujanggibyeolgi (Dance of Nine Skills); Wangmodaegamu (mass dance for the prosperity of the king); Suyeonjang (Dance of Longevity); Yeonhwadaemu (Lotus Dance); Oyangseon (Dance of the Five Immortals); Heonseondo (Peach Offering Dance); Dongdong (Dance to Musical Chant); Mugo (Drum Dance); and Muaemu (Dance of Non-hindrance). The ritual dances included Ilmu, which is a line dance.

The roots of both events can be traced to much earlier rites to the gods of heaven, earth, and the ancestors. The ceremonial part of the rites was followed by drinking, singing and dancing that lasted long into the night. In the court, the influence of such rites was manifested in the music, songs and dances that were performed at various ceremonies and banquets, and led to the development of court dance as a separate genre of performing arts, apart from religious dance as seen in the Yeondeunghoe and Palgwanhoe festivals.

Expanded Reference Compilation of Documents (Jeungbo munheon bigo) contains dance related records from the ancient state of Gojoseon (2333 BCE-108 BCE) to the Joseon Dynasty (1392-1910). The following are among the important references relating to dance.

1) Jizi, an individual known in Korean as Gija, came to Korea from China together with 5,000 of his followers. They brought with them many things, including poetry and prose, music, rites, shamans, and crafts. Jizi founded the Gija-Joseon state around

1122 BCE and the "eastern barbarians" (the Koreans) presented Jizi with music and dance. In the ancient Chinese text, *Rites of Zhou* (*Zhouli*), these are indicated as music and dance that make all things from the ground grow.

In addition, the Chinese text *Collected Commentary on the Five Classics* (*Wujing tongti*) mentions that the music and dance of the "eastern barbarians" features dancing with spears, which is based on the theory of yin and yang and helps all things to grow in all four seasons. This refers to the same dance described in the *Rites of Zhou*, and to the dance known as Jiseonmu, or the Dance of the Earthly Immortals.

2) In the Mahan confederacy (around 100 BCE-300 CE), before the seeds were sown in the fifth month, rites were held to the gods of heaven, earth, and the ancestors, and these were followed by drinking, singing and dancing that lasted all night. When the crops were harvested in the 10th month, rites were held to heaven featuring a shamanic bell ringing dance. Similar rites were also held in other states such as Jinhan, Yemaek, and Buyeo, covering a period from the 2nd century BCE to the 5th century.

3) During the Silla Kingdom, envoys were sent to the Tang Dynasty court in China and presented song and dance performed by women.

In 32, the ninth year of King Yuri's reign, the women and children of the six ruling clans of Silla were divided into two teams for a month-long weaving competition starting on the fifteenth day of the seventh month. The team that managed to weave more hemp cloth was awarded prizes and presented with food and drink

made by the losing team. Together they celebrated the end of the competition with feasting, singing and dancing. One woman from the losing team performed a song and dance lamenting their defeat. This song became known as "Hoesogok" and the weaving festival as Gabe.

Various musical compositions and dance were created throughout the Silla period, such as "Dora-ak" (Song to the Moon) during the reign of King Talhae, and while assimilating various influences through trade with Japan and China, the basic framework for Korean court music and dance was formed.

4) In the Goguryeo Kingdom male dancers were depicted in tomb murals as dressed in robes of five colors, with their hair in topknots, their foreheads painted crimson and wearing accessories of gold and jade. The women dancers wore jackets with long sleeves, skirts and pants, and long necked shoes.

5) In 1073, the 27th year of the reign of King Munjong of Goryeo, 13 female entertainers, or "female disciples," including a woman named Jinqing, danced at the annual Lotus Lantern Festival (Yeondeunghoe). During the Goryeo period a music department was established at the court, and court music and dance were systematized.

6) In the early Joseon Dynasty, Goryeo court dances were recreated based on Joseon ideological elements. The form of *dangak jeongjae* of the Goryeo period was adopted to create nine new Chinese-style court dances. Seven new native court dances were also created, including the line dance Ilmu, performed at the ancestral rites at the royal shrine, Jongmyo, and at the national shrine honoring

Confucius, Munmyo. In the late Joseon period, four new Chinese-style dances were created as well as twenty-seven new native court dances, all of which were performed at court ceremonies and banquets.

Throughout all of these periods there were many exchanges of musical instruments with China, and hence Chinese music had a significant impact on Korean court dance.

2. Major Court Dance Movements

The themes and major movements of court dance can also be traced through documentary evidence.

Korean court dance deals with several themes: 1) wishing for the longevity of the king, 2) celebrating the anniversary of the king's ascension to the throne, 3) praising the virtues of the court, 4) extolling the benevolent rule and politics of the king, 5) blessings for the prosperity of the royal family, and 6) wishing for the peace and prosperity of the nation.

Being an art form dealing with the aforementioned subject matter and performed at events in royal palaces, court dance was not an expression of individual emotion or sentiment but rather of national character and inclinations. In general, it is dignified, slow and elegant and follows strict rules and procedures.

During the Three Kingdoms period and Goryeo Dynasty when Buddhism was the ruling ideology, court dance featured many Buddhist influenced movements. During the Joseon Dynasty, however, Buddhism was suppressed in favor of Confucianism and this had a direct impact on dance movements and formations, resulting in very restrained orderly movements whereby expression of emotion was

suppressed.

The restraint that characterizes court dance presents a great contrast to folk dance, which is rooted in rites to the ancestors and the gods of heaven and earth from prehistoric times and allows free expression of personal emotions. As an art of the ordinary people, folk dance can be performed differently by everyone who takes part, depending on their feelings at the time. Hence, folk dance has changed greatly over time and makes great allowance for improvisation. Participants feel free to interpret moves as they wish. Court dance, however, is performed according to fixed movements developed in the royal court from the Silla period through the Joseon Dynasty.

Historical documents describe a total of 58 basic court dance movements, which are based on eastern philosophies, particularly the theory of yin and yang and the five elements (water, wood, fire, earth, and metal), and express the concepts of harmony and conflict arising from the flow of energy from one element to the next.

Although it is not possible to provide descriptions of all these movements here, some of the major ones can be described as follows.

1) *Inmu*

Inmu refers to a set of basic movements which are the most common found in Korean court dance: the dancers turn to face north in the direction where the king sits, turn inward so they are face to face, and turn outward so they are back to back. These movements represent the concepts of mutual generation and mutual conquest based on the cyclical movement of the five elements, which are wood, fire, metal, earth and water. Mutual generation refers to the way one element gives rise to the next: wood gives rise to fire, fire gives rise to earth, earth gives rise to metal, and metal gives rise to water. Mutual conquest refers to the way one element consumes another: wood overcomes the earth, earth conquers water, water quenches fire, fire liquefies metal, and

metal cuts wood.

Inmu performed by two dancers

Basic formation	Turning inward	Facing north	Turning outward	Facing north
N W ◖●◗ E S	↱↰ ◖◖	◖● ↰↱	↖↱ ◖◖	◖● ↱↖
Facing the king	Mutual generation	Facing the king	Mutual conquest	Facing the king

Basic *inmu* moves performed by two dancers

Inmu performed by five dancers

Basic formation	Step 1	Step 2	Step 3	Step 4
◖●●●◗	↖↰↱↰↱ ◖◖◗◖◗	◖●●●◗	↱↱↰↱↱ ◖◖◖◗◗	◖●●●◗
Facing the king	Turning back to back /Turning face to face	Turning to the north	Turning face to face/ Turning back to back	Turning to the north
	Mutual conquest/ Mutual generation	Facing the king	Mutual generation/ Mutual conquest	Facing the king

These moves are performed by five dancers in such court dances as the Dance of Cheoyong and Dance of the Five Immortals.

2) *Sangdae*

This is a set of moves similar to *inmu*: the dancers turn to face each other and dance, then turn to face the north, then turn back to back, then face north again. They are a feature of the Cheoyongmu, Oyangseon, Yeonbaekbokjimu, Choehwamu, and Jangsaengboyeonjimu.

Sangdae performed by four dancers

Basic formation	Facing inward	Face to face	Facing north	Back to back	Exit	Facing north
N W ◖●◗ E ◖● ●◗ S						
Stand facing the north	Turn to face each other	Dance face to face	Turn to face the north	Turn back to back	Return to starting position	Turn to face north in starting position

3) *Mujak*

This move refers to the raising of both arms to the sides at shoulder height. This move is made at the start of every dance and hence signals the beginning of the performance.

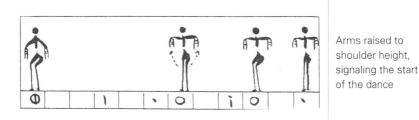

Arms raised to shoulder height, signaling the start of the dance

4) *Palsumu*

Palsumu literally means "eight hands [arms] dance" and refers to the repeated movement of raising the arms in the shape of the Chinese character for "eight"(八), and resting the hands on the shoulders for a moment before lowering the arms again, making the same shape. When the arms are lowered the right hand falls in front over the left side and the left hand behind, and the next time they are lowered the left hand falls in front over the right side and the right hand behind, representing the crossing or exchange of yin and yang.

Palsumu movement 1

Beginning position	Step 1	Step 2	Step 3	
Right Left	Right Left	Right Left	Right Left	
Arms down at the sides	Raise arms in "八" shape and place hands on shoulders	Lower arms in "八" shape	When the arms are lowered in Step 2, the right hand falls in front and the left hand behind. The left hand represents yin and the right hand yang.	

Palsumu movement 2

Beginning position	Step 1	Step 2	Step 3	
Right Left	Right Left	Right Left	Right Left	
Continuing from Step 3 in Movement 1.	Raise arms in "八" shape and place hands on shoulders	Lower arms in "八" shape	When the arms are lowered in Step 2, the right hand falls in front and the left hand behind. The left hand represents yin and the right hand yang.	

5) *Hyeopsumu*

This is a movement performed in exactly the same way by all the dancers at the same time.

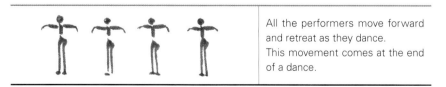

	All the performers move forward and retreat as they dance. This movement comes at the end of a dance.

6) *Nakhwayusu*

Nakhwayusu means "falling flowers on flowing water" and refers to any variation of movement that involves the lowering of the hands behind, one at a time, like flowers falling on water and drifting away, while turning around on the spot, first to the left and then to the right.

7) *Ilbuliljeon*

This is one of the variations of *nakhwayusu* and means "one sweep, one turn."

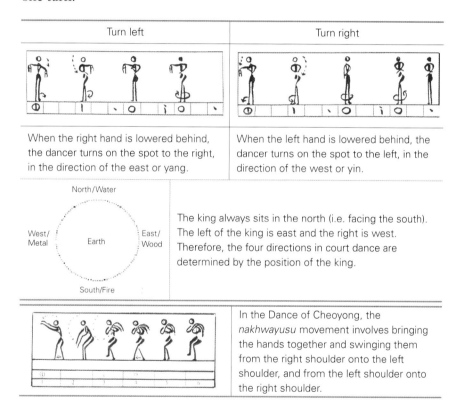

Turn left	Turn right
When the right hand is lowered behind, the dancer turns on the spot to the right, in the direction of the east or yang.	When the left hand is lowered behind, the dancer turns on the spot to the left, in the direction of the west or yin.

The king always sits in the north (i.e. facing the south). The left of the king is east and the right is west. Therefore, the four directions in court dance are determined by the position of the king.

In the Dance of Cheoyong, the *nakhwayusu* movement involves bringing the hands together and swinging them from the right shoulder onto the left shoulder, and from the left shoulder onto the right shoulder.

8) *Sasumu*

This movement is said to originate in a dance performed by four young Silla warriors (*hwarang*) at Mt. Geumgangsan, famous for its beautiful scenery, when they roamed around the country in search of

auspicious sites as part of their training. The dancers stand in square formation, one at each corner representing the four cardinal directions, and raise their arms out to the sides.

The four hwarang warriors were named Yeongnang, Sullang, Ansang, and Nakseokhaeng, and together they were known as the *saseon*, or four immortals. They roamed the mountains training their bodies and cultivating their minds. It is said that at Haegeumgang on Mt. Geumgangsan, a particularly beautiful spot, the four warriors danced with their arms stretched out at their sides, as in the illustration. In the Silla period, this dance was called *saseonmu*, meaning "dance of the four immortals." But in the Joseon Dynasty, the dance was changed slightly to focus on the outstretched hands rather than the arms and was renamed *sasumu*, meaning "four-hands dance."

9) *Hoeran*

Hoeran means "turning bird," and this movement is meant to resemble a sparrow gliding in the sky. The arms are stretched out to the sides at shoulder height and the dancers turn on the spot to the left and then the right.

Turn to the left	Turn to the right
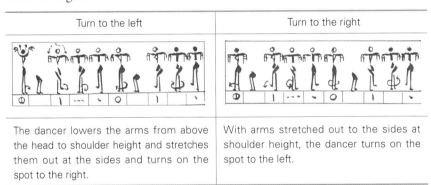	
The dancer lowers the arms from above the head to shoulder height and stretches them out at the sides and turns on the spot to the right.	With arms stretched out to the sides at shoulder height, the dancer turns on the spot to the left.

10) *Isugojeo*

The name of this movement means "high and low sleeves" and constitutes the alternate raising and lowering of the arms, gently tossing the long sleeve ends up and down as they move forward and backward. The raised arm is arched in front at chest height and the lowered arm is held down at the side at a 45-degree angle. This

movement is also called *ilgo-iljo*, which means "one high, one low." It is performed by the dancers standing in two columns with the dancers on the left side putting the left foot forward first, and those on the right side putting the right foot forward first.

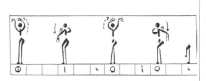

Starting with both arms raised above the head, both arms are lowered first to the left side with the right arm held arched in front at chest height and the left arm held down at the side at a 45-degree angle. The two arms are raised and lowered again, this time to the left with the left arm held arched in front at chest height and the right arm held at the side at a 45-degree angle.

Yin and yang in court dance

For all movements, the inside foot is put forward first. When the dancers are standing in columns or in a row, the inside foot is the left for those on the left side and the right foot for those on the right side. The same principle also applies to the movement of the arms. This movement of the arms and legs is also a reflection of the harmony of yin and yang, represented by the right and the left, respectively.

YIN AND YANG IN DANCE MOVEMENTS

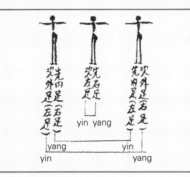

In all court dance movements the inside foot is put forward first.

POSITIONING OF THE KING AND THE DANCERS

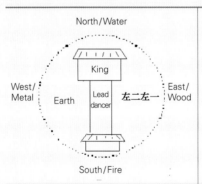

The king sits in the north, representing water. The left of the king is the east (wood), and the right is the west (metal). The right is yin and the left yang.
The mother immortal, or lead dancer, stands in the middle (earth).

The theory of yin and yang and the five elements is also important in determining the basic positions of the dancers. The king always sat in the north to face south, the north representing water and the south fire. Naturally, the dancers had to face the king, so they basically

faced north. In the center, representing earth, stood the lead dancer called *seonmo*, or "mother immortal." Though the name may suggest the lead dancer was always a woman, this is not the case. In principle, female dancers could not perform before the king, so in the presence of the king, court dance was performed by males, including a male lead dancer. The rest of the performers were arranged west and east (left and right) of the lead dancer, west standing for metal and east for wood.

II.
Court Dance of
the Three Kingdoms Period

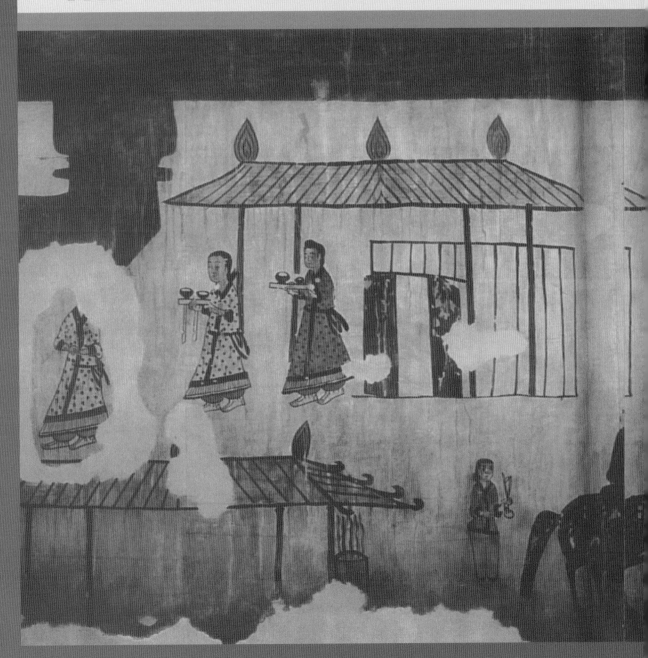

1. Goguryeo Dance

A. Historical Background

As no written records about the court dance of the Goguryeo Kingdom (37 BCE-668 CE) have been found, information has been gleaned from Goguryeo tomb murals, Chinese documents, and *Akji* (a monograph on ceremonies and music) from the *History of the Three Kingdoms* (*Samguk sagi*).

Many of the tomb murals of Goguryeo feature images of musicians and dancers. Tomb No. 5 of Ohoebun (five 6th-century tombs) features a musician playing a flute descending from heaven on the back of a dragon[Fig. 1] and an immortal riding a crane and a dancing boy riding a dragon descending from heaven[Fig. 2]. The Tomb of Dancers (Muyongchong) from the late 4th to early 5th century shows two women under the guidance of another woman going to the temple to give offerings to Buddha while four dancers

Fig. 1
Dragon mural in Ohoebun Tomb No. 5, 6th century

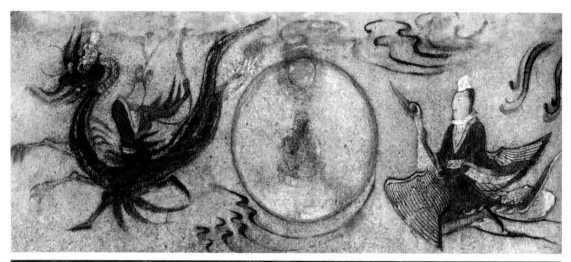

Fig. 2
Mural of celestial maiden
riding a crane, Ohoebun
Tomb No. 4, 6th century

Fig. 3
Dance scene from the
Tomb of the Dancers,
late 4th-early 6th century

are performing under the guidance of a lead dancer[Fig. 3]. The
Deokheung-ri tomb murals, estimated to date to the early 5th
century, feature a dancing celestial maiden descending from heaven
with a torch in one hand and a banner in the other[Fig. 4] and another
celestial maiden descending with a heavenly peach in one hand and a
banner in the other[Fig. 5]. It is conjectured that the dance depicted in
the murals matches the Goryeo Dynasty court dance Heonseondo,

or peach offering dance.

In Heonseondo, according to historical records, three celestial maidens come down from heaven under the guidance of two pole bearers to offer a heavenly peach to the king and sing and dance to pray for his health and longevity. The colors and lines bring the images in the tomb murals to life, and clearly the dynamism of the people had already been incorporated in Goguryeo dance forms.

B. Dances

In the kingdom of Goguryeo an annual festival called Dongmaeng was held in the 10th lunar month. Harvest rites were held in honor of the gods of heaven and earth, the ancestors, and the stars, with offerings of newly harvested grains. The people drank and made merry with song and dance all day and into the night. At the same time, Dongmaeng was a solemn event to honor the spirits of the ancestors worshipped by the ancient tribes.

The History of the Three Kingdoms describes the costumes worn by musicians and dancers as follows:

1. "The musicians wear red silk hats with bird feathers and long yellow sleeves bordered with red and wide pants with red leather shoes tied with laces of five colors."

2. "Of the dancers, four have their hair in a topknot wound in a red headscarf decorated with gold tassels. Two of them wear yellow jackets and skirts with red and yellow pants, and two of them wear yellow jackets and skirts with yellow pants. Their sleeves are very long and they wear black leather shoes."

Fig. 4
Celestial maiden in
Deokheung-ri Tomb, 5th
Century

It is not known specifically which dances these records refer to, but the colors of the clothing and the dance movements pictured in Goguryeo tomb murals suggest that the dances of northern India, Tibet, and Kazhakstan had been introduced to the country. The excavation of Anak Tomb No. 3 in 1949 revealed a mural featuring the owner of the tomb in a cart, a military band, officials riding horses, and people performing a sword dance, an indication that ritual dance had already been incorporated into large processions. The mural in the inner chamber of the tomb features dancers who appear to be moving to music played on instruments that resemble the *gayageum* (12-string zither) and a long bamboo flute. Though the exact forms of Goguryeo dance are not known, written records indicate the existence of a wide variety of well-

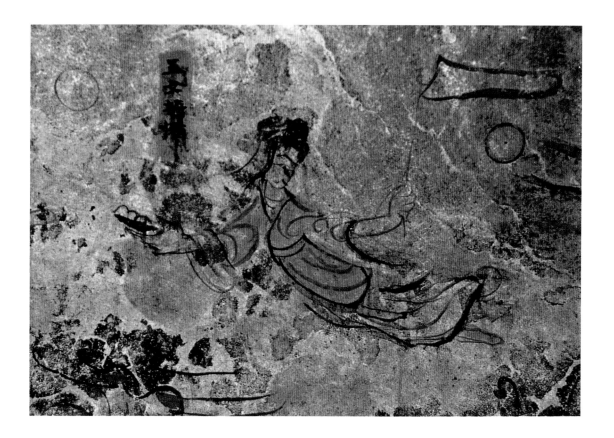

developed dances performed solo, in pairs, in groups of three, and in groups of seven.

2. Baekje Dance

A. HISTORICAL BACKGROUND

The kingdom of Baekje (18 BCE-660 CE), which was founded by Onjo, the third son of Goguryeo's founder, Jumong, had active cultural exchange with China. In 384 (1st year of the reign of King Chimnyu), the Indian monk Mararanta came to Baekje by way of Jin Dynasty China, and both Confucianism and Buddhism flourished.

Unlike Goguryeo, which had absorbed much of the culture of northern China, Baekje was influenced by the southern dynasties of China and developed unique arts and culture, considered to be warm and gentle, as represented by the smiling-face motif found on many Baekje relics.

B. Dances

As Baekje was founded chiefly on the basis of the existing Mahan confederacy, it continued the farming customs and religious rituals of Mahan. Seeds were sown in the fifth month, the crops were harvested in the tenth month, and rites to the gods of heaven, earth and the ancestors were held at those times, with all the people joining in to sing, dance and make merry.

In reference to a Baekje dance, *History of the Three Kingdoms* states, "The two dancers wore red jackets and skirts, black leather shoes, and long coats." But as there is no record of the dance itself it is not possible to know exactly what form it took, nor which specific dance the record refers to. The music was generally the music of the southern dynasties of China.

3. Silla Dance

A. Historical Background

King Beopheung, the 23rd ruler of the Silla Kingdom (57 BCE-935 CE), officially recognized Buddhism as the state ideology in 527. Later, Silla absorbed the neighboring tribes, and in 677, King Munmu unified the three kingdoms of Silla, Baekje, and Goguryeo, with Silla assimilating the culture of the other two kingdoms. Unified Silla continued cultural exchange with the Tang

Dynasty of China and established an office called Eumseongseo to be in charge of music, drama and dance for the court. It also adopted Buddhism as the ruling ideology to protect the nation and ushered in a golden age of Buddhist culture, which was later transmitted to Japan.

B. DANCES

1) PRE-UNIFICATION

In the early days of Silla some dances were accompanied by the *gayageum* (12-string zither) and singing, and some only by the *gayageum*. During the Silla period, performing artists were organized into a rank system. Records state that in 468, the tenth month of the eighth year of King Munmu, a 15-year-old boy named Neungan performed a dance called Gayajimu. Also around this time a sword dance was introduced to the court. It was based on the story of a Silla youth named Hwangchangnang who entered Baekje as a servant and died in an attempt to kill the king while doing the sword dance. In the capital, people commemorated this incident by wearing masks of Hwangchangnang and dancing, and this formed the basis of the court version of the Sword Dance (described more fully later).

2) POST-UNIFICATION

After the unification of the three kingdoms in 668 and the establishment of Unified Silla, dance developed into a performing art involving the musical accompaniment of song and six instruments: three string instruments—*geomungo*, a six-string zither; *gayageum*, a twelve-string zither, and *hyangbipa*, a kind of lute—and three bamboo instruments—*daegeum*, a large transverse flute; *sogeum*, a small transverse flute, and *daego*, a large drum. Compositions featuring the

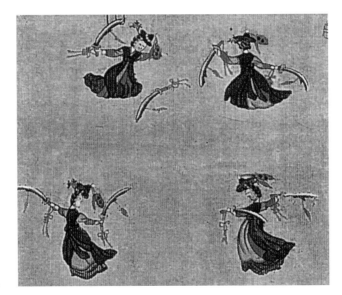

hyangbipa, a Goguryeo instrument that came from the regions west of China, and a Tang instrument called *bak* (clappers), as well as the *haegeum* (two-string fiddle), *janggo* (hourglass drum), and *piri* (flute) developed into orchestral works and accompaniment for various dances.

The major Silla dances were the Sword Dance, the Dance of Cheoyong, the Dance of Non-hindrance, and miscellaneous performances called the Five Amusements.

(1) Geommu: Sword Dance

The generic term for "sword dance" is *geommu* or *geomgimu*. One of the most famous versions of the sword dance is Hwangchangnangmu, named after a youth called Hwangchangnang, the son of General Bumil of Silla. As mentioned earlier, Hwangchangnang attempted to murder the Baekje king while performing the sword dance at the Baekje palace. He was caught, but because he was so young (between 12 and 15 years old), he was not killed but was sent back to Silla. His father then sent him into battle in order to distinguish himself

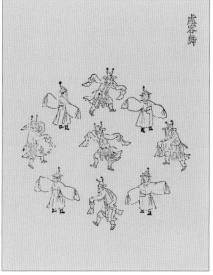

Fig. 7
Dance of Cheoyong from a folding screen depicting a royal banquet from 1848. The original dance from the Silla period was recreated during the reign of King Sejong of the Joseon Dynasty.

Fig. 8
Dance of Cheoyong depicted in the *Royal Protocol of the Banquet of 1828* (*Muja jinjak uigwe*)

in service to the nation, but he was captured by the Baekje general Gyebaek who cut off his head and sent it to back to his father. From that time the Silla people wore masks of Hwangchangnang and danced the sword dance in his honor. Originally performed by the common people, the sword dance was introduced to the palace where it developed into a form of court dance that has been handed down to the present.

(2) Cheoyongmu: Dance of Cheoyong

A record about the Dance of Cheoyong is found in Volume 2 of *Memorabilia of the Three Kingdoms* (*Samguk yusa*):

Heongang, the 49th king of Silla, took an inspection journey around his kingdom. All the houses were in good order and his progress was accompanied by music and song. The weather was fair and the king went as far as Gaeunpo [today's Ulsan]. He and his retinue were resting by the waterside on their way home when suddenly clouds and fog enveloped them, making it impossible to see ahead.

The court weather official (*ilgwan*) said the fog was the work of the Dragon King of the East Sea and that they would have to do something to appease him. So the king ordered the construction of a temple nearby. When the king gave the order, the clouds lifted and the fog disappeared. From that time the place was called Gaeunpo, which means "open cloud beach." The Dragon King was pleased and appeared before King Heongang with his seven sons, singing the king's praises and dancing.

One of the sons followed King Heongang back to the palace where he became a high court official. His name was Cheoyong and the king chose a beautiful woman for his wife. Lured by the wife's beauty, the God of Disease (specifically, smallpox) turned himself into a human being, stole into Cheoyong's house when he was away, and slept with her. When Cheoyong returned home and found two people lying in his bed he began to dance and sing this song:

> I strolled the streets of the capital till late at night
> Under the bright light of the moon
> When I returned I found
> Four feet in the bed
> Two of them are mine [his wife's]
> But to whom do the other two belong?
> What will I do about the two
> That have been stolen from me?

The God of Disease then appeared and knelt down before Cheoyong saying, "I desired my Lord's wife and committed this crime but my Lord did not get angry. This has moved me deeply and from this day I will not enter any house that bears your picture on the gate."

From that time people pasted pictures of Cheoyong on their gates to

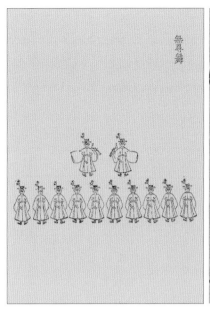
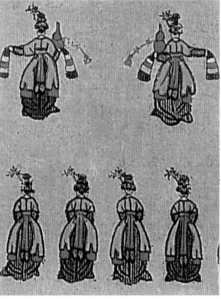

Fig. 9
Dance of Non-hindrance
depicted in the *Royal
Protocol of the Banquet of
1902 (Imin jinyeon uigwe)*

Fig. 10
Dance of Non-hindrance
from a folding screen
depicting a royal banquet
held in 1901

chase away evil spirits. This custom is called *byeoksa-jingyeong*, which means driving away evil spirits and inviting good fortune.

During the Goryeo Dynasty the Dance of Cheoyong was performed by one person wearing a black robe, but in the time of King Sejong (r. 1418-1450) of the Joseon Dynasty it was rearranged into a dance for five people. It was also incorporated into a performance combining the crane dance and lotus dance called Hak-yeonhwadae-hapseolmu. It was performed on the night before New Year's Eve as part of court rites to chase away evil spirits (*narye*). In later times, the Dance of Cheoyong was performed separately in the court. On January 8, 1971 the government designated the dance Important Intangible Cultural Property No. 39, and it has been passed on to the present.

(3) Muaemu: Dance of Non-hindrance

Volume 4 of *History of the Three Kingdoms* (*Samguk sagi*) states that the great monk Wonhyo (whose secular name was Seol) was born in the

village of Baljichon in Gyeongsan, Gyeongsangbuk-do Province. In a dream before she conceived, Wonhyo's mother saw a meteor coming to embrace her, and when it came time for her to give birth she saw clouds of five colors cover the ground. These things suggest that from birth Wonhyo was special.

When Wonhyo became a Buddhist sage, he said he wished to take care of the pillars holding up heaven. Hearing this, King Taejong of Silla interpreted these words in this way: "Venerable Wonhyo wishes to gain a son from a noblewoman." There was a palace called Yoseokgung where Princess Yoseok lived alone. The king ordered one of his officials to take Wonhyo there but on the way to make him fall into the water and wet all his clothes. The official led Wonhyo to Yoseokgung and made him take his clothes off to dry. Wonhyo ended up spending the night at the palace and sleeping with the princess. The princess conceived and gave birth to a child named Seolchong.

As a result of this incident, Wonhyo exchanged his monk's robes for the clothes of a layman, and called himself Soseong Geosa ("small monk among ordinary people"). He made an instrument from a gourd, like the one used then by itinerant clowns, and composed a song titled "Muae-ga," which means "song of non-hindrance," taken from a passage in the Buddhist *Avatamsaka Sutra* which states that the completely free person lives and dies along one road. Taking his gourd instrument, Wonhyo went from village to village singing and dancing as a way to propagate Buddhism, and the people followed him. While living at Bunhwangsa Temple Wonhyo gave away all his belongings and attained enlightenment as a result of his virtues and practice of asceticism.

Afterward the Silla people sang, using a gourd-shaped instrument and danced. This dance came to be known as Muaemu, or the Dance of Non-hindrance. The idea of non-hindrance is to abolish all evil and

achieve a time of peace and prosperity.

It is not possible to know how the dance was performed originally during the Silla period, but the version recreated and performed in the court during the Joseon Dynasty has been handed down to the present.

(4) Sangyeommu: Silla Mask Dance

This dance dates to the reign of King Heongang (875-885) of Silla and is described in *Memorabilia of the Three Kingdoms* (*Samguk yusa*) as follows:

> The king walked to Poseokjeong when the god of Namsan [South Mountain] appeared before the king and started to dance. No one else could see the god dancing, only the king. The king imitated the god and in this way everyone else could see the dance as well.

The god's name was Sangsim, or Eomusansin, which means "the king's dance with the mountain god." It is said that the king commanded an artist to paint the dance as he performed it to enable its transmission to future generations. The king is said to have worn a white beard when dancing but this is not reflected in surviving versions of the dance.

(5) Japhui: Miscellaneous Amusements

Five kinds of miscellaneous amusements, including mask-dance dramas and a lion dance, were described in a poem by Choi Chi-won, but none have survived to the present. According to the poem the five amusements are as follows:

Geumhwan: Golden Balls
The whole body moves and the two arms shake

Gold balls roll powerfully here and there
The moon glows and the stars shine
And even the whales dance on the quiet sea.

Woljeon: Top of the Moon

The neck disappears inside shoulders high
But the topknot pokes out at the top
As the song begins the laughter grows loud
And the evening flag flutters all night.

Daemyeon: Grand Mask

Who is the man in the golden mask
Waving his whip to chase evil spirits away.
Stopping to dance as he runs away slowly, slowly
Wavily, wavily like a phonenix dancing.

Sokdok: Dance from Sogdia

Strangers with dark faces
Crowd into the yard and dance like birds
The drum booms, the wind rustles
Running south to north without end.

Sanye: Lion Dance

Coming ten thousand *li* from the west
Fur sparse and caked with dust
Shaking the head and waggling the tail
The elder of all beasts are you the lion.

Silla maintained exchanges with China, Japan, and the regions west of China and held various annual festivals such as Palgwanhoe and Yeondeunghoe as well as rites to the gods of heaven, famous mountains,

large rivers, and the Dragon God in the eleventh month. Along with the king and the gods, all the people joined together in a festival of song, dance, and 100 plays (*gamu-baekhui*). As these events were held under the auspices of young Taoist groups and Taoist homes where immortals were said to reside, it can be surmised that Silla court dance was steeped not only in Buddhism but also Taoism.

III.
COURT DANCE OF
THE GORYEO DYNASTY

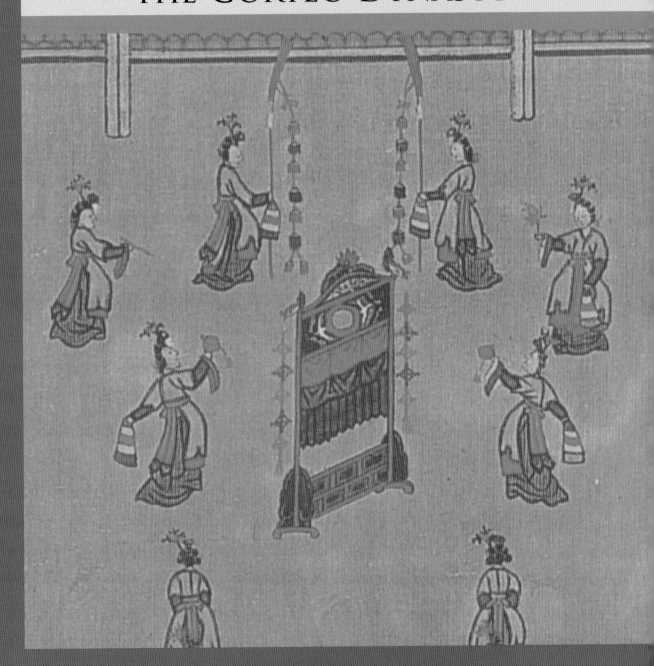

1. Historical Background

The Goryeo Dynasty (918-1392), founded by Wang Geon, assimilated the art and culture of Silla and Baekje as well as the social and political systems of Silla and the Tang Dynasty of China. It also adopted Buddhism as the state ideology, which resulted in the development of a culture based on both Buddhism and Confucianism.

A centralized government was established in the reign of the 11th ruler, Munjong, and at the same time music and dance flourished. In late Goryeo Confucianism and Neo-Confucianism were introduced to the country and institutional changes were made, leading to the rejection of Buddhism.

Dark days followed but the arts continued to develop. Advances were made in astronomy, and movable metal type was invented, Goryeo celadon reached new heights, and progress was made in the study of the Chinese classics. The Confucian philosophy of propriety and music especially flourished. The *Book of Rites* (*Liji*) states that politics means knowing music, and that by knowing music one comes to know politics. This idea, expounded in the *Book of Music* (*Yuejing*), was considered very important in Goryeo and influenced the development of music in two streams: *hyangak*, native Korean court music influenced by shamanic and Buddhist rituals; and *dangak*, which is rooted in the music of China's Tang Dynasty. These two types of music were reflected in native court dance and court dance of Chinese origin, respectively.

2. Dances

From the beginning of the Goryeo Dynasty, Silla festivals such as Palgwanhoe and Yeondeunghoe were continued.

A. Chinese-Style Court Dance of the Goryeo Dynasty

The History of Goryeo (*Goryeosa*) mentions Tang court dance of the Goryeo Dynasty as follows:

> In the 2nd month of the Eulhae year in the 27th year of the reign of King Munjong [1073] it was requested that 13 female disciples [female entertainers], including Jinqing, be allowed to perform Dapsahaenggamu at the annual Yeondeunghoe festival, to which the king gave his consent. In the 11th month of the Sinhae year the king hosted the Palgwanhoe festival and afterward watched a musical concert at Sinbongnu Pavilion when the female disciple Chuying told the king about the new dances Pogurak and Gujanggibyeolgi. Pogurak is performed by 13 dancers and Gujanggibyeolgi by 10 dancers.

At the Yeondeunghoe festival held in 1077 the king went to Junggwangjeon Pavilion where he watched Wangmodaegamu, a mass dance wishing for the prosperity of the king. It is recorded that 55 dancers formed the characters for "long live the king" (君王萬歲) and "peace to all mankind" (天下太平).

The chapter on Tang music in the music monograph in the *History of Goryeo* includes an appendix that lists various dances such as Heonseondo, Suyeonjang, Oyangseon, Pogurak, and Yeonhwadaemu.

Much Chinese music and dance was introduced to Korea by the Tang Dynasty from the time of King Mokjong (998-1008) through King Yejong (1106-1122). Music and dance by professional entertainers reached a peak during the reign of Emperor Renzong (1010-1063) of Northern Song, which corresponds to the early days of Munjong (r. 1036-1048). It is believed that the earliest performances were Heonseondo in 990-1056 and Suyeonjang, Oyangseon, and Yeonhwadae performed by female entertainers at the annual Yeondeunghoe festival in 1073. The exact dates, however, are not known.

(1) Heonseondo: Peach Offering Dance

Heonseondo originated in a classical poetic song of the Song Dynasty. Goryeo musicians composed a piece intended to accompany dance, and used it as a kind of celebratory performance that was handed down intact to the Joseon Dynasty.

As it is performed today (based on descriptions in historical documents), the dance features a celestial maiden who descends from heaven carrying a heavenly peach, which she presents to the king, and then performs a dance wishing for his longevity. It is performed by 18 female dancers carrying ceremonial properties and two pole bearers (performers carrying red bamboo poles), the lead dancer, two attendant dancers, and three more female dancers carrying ceremonial parasols. First the two pole bearers come forward slightly and sing the opening refrain:

> We come to the palace from the five great mountains afar
> Offering the beautiful fruit of a thousand years
> To present good fortune and auspicious omens
> We look upon the face of the king and present this song.

After the song the lead dancer, called *wangmo* or *seonmo*, which means "immortal mother," comes forward slightly. A dancer enters from the east carrying the heavenly peach on a tray and, kneeling down, presents it to the immortal mother who holds the tray up and sings "Wonsogahoesa" (song of the party at Wonso), a portion of which translates as follows:

> Enjoying the wonderful feast and spring views of Wonso
> Enjoying this lovely event at Sanghyanggung
> The king faces north with happiness on his brow
> Emperor Shun in long robes sits deep in the palace with arms folded.

She then places the tray on a table and bows down on bended knees. She rises and moves to the top of the column where the other dancers are standing in formation, then dances using her long sleeves. Then turning to the right and looking to the north, facing the king, she sings two verses of the main song.

After the song the two attendant dancers come forward and dance Suborok ("receiving the precious epistle") and sing a song announcing the arrival of the warm east wind:

The east wind comes with a message of warmth
The beautiful energy all around gradually grows softer and happier…

The two attendants then return to their places and the lead dancer, comes forward again and sings "Haedonggeumilsa" (song about Korea):

Peace reigns over this eastern nation [Korea] today
In happiness the king and his court look upon the banquet
The fans are spread open and the king's throne shines

Now the painted screen is rolled up
Auspicious energy fills the air
[...]

The lead dancer then moves back to her place and the pole bearers move forward to sing the closing refrain:

Putting our clothes in order for a moment we step back
Intending to return following the path of the clouds
We bow twice in front of the courtyard
And following each other we leave.

The lead dancer and two attendant dancers come forward and bow twice, then all the dancers leave by the southern exit and sit down.

(2) Suyeonjang: Dance for the Longevity of the King

Though the exact date Suyeonjang was created is not known, many books of royal protocol (*uigwe*), manuals and musical documents state that Song Dynasty China had a piece of music titled "Suyeonjang" from the palace of the celestial maidens, which was performed on festive days to wish for the longevity of the king. In Goryeo this piece of music was put to dance and was used at court banquets. It was also used in the same way in the Joseon Dynasty.

During the Goryeo Dynasty the dance was performed by eighteen female entertainers holding ceremonial implements and standing in two lines. There were two pole bearers and sixteen dancers in four groups of four. In the Joseon Dynasty it was performed by eight dancers. First the two pole bearers come slightly forward and sing the opening refrain:

Fig. 13
Detail of the Peach Offering Dance from a folding screen depicting a royal banquet held in 1848

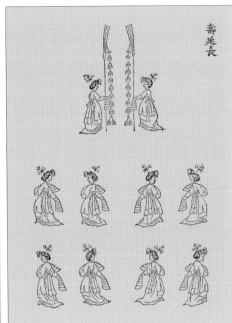

Fig. 14
Dance for the Longevity of the King from a folding screen depicting a royal banquet held in 1901

Fig. 15
Dance for the Longevity of the King from the *Royal Protocol from the Banquet of 1877* (*Jeongchuk jinchan uigwe*)

A beautiful rainbow envelops the palace sending a good omen
Auspicious clouds shine on the light of dusk
Envoys from all nations come to pay their respects
As we play Boheoja at the pear blossom pavilion.

The two pole bearers move back, one standing at the left hand side of the stage and the other on the right, and eight dancers come forward to sing the two verses of the main song:

First verse
Red clouds, shining colors, reflect upon each other,
Officials are crowded tightly around the throne
Filling the courtyard like silken flowers of all colors
And the joyous sounds of a celebratory feast are heard
[…]

Second verse

Opening a thousand years of tradition and enjoying success

With one mind we offer our congratulations on the full moon

We offer liquor in a cup of jade

Gallant heroes who often drink from jeweled cups

Enjoy an era of peace for a million years.

When this is finished the dancers on the left side face outward toward the west and those on the right side face inward. Each side circles in a different direction and two dancers each stand in the four directions, those in the east, west, and south kneeling down, while those in the north face each other, then turn back to back, and then face north toward the king. Then the other dancers rise and, lifting their outstretched arms, they move in a big circle.

When all four groups reach their original positions again they come forward and turn in circles with arms spread out at their sides. Then the pole bearers come forward and sing the closing refrain:

A wonderful scene in a time of peace

The jade palace is wide and even the sun is long

The scent of flowers mixes with the smell of incense and flows over the silken mat

The beautiful blessings of heaven are brought and floated in a gold wine cup.

(3) Oyangseon: Dance of the Five Immortals

According to the *Gazetteer of the World during the Taiping Period* (*Taiping huanyuji*), a Tang Dynasty poem by Li Qunyu describes the time Gaogu became prime minister of the state of Chu. Five celestial maidens descended from heaven riding on rams with coats of different colors and handed to Master Anqi Sheng, a hermit known for his great filial piety, a grain stalk with six ears of rice on it.

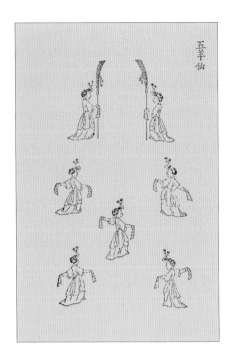

Fig. 16
Dance of the Five
Immortals depicted in the
Royal Protocol of the
Banquet of 1829 (*Gichuk*
jinchan uigwe)

Adapted from a dance originally performed in China, Oyangseon symbolically represents the Chinese Master Anqi Sheng handing out the ears of rice to the villagers to plant for food. In form, there are eighteen female dancers holding ceremonial implements standing in two rows, with two pole bearers standing in front of them. Behind the eighteen dancers are four attendant dancers standing to the east and west, with the lead dancer standing in the middle. At the very back are four dancers holding ceremonial parasols. The pole bearers come forward to sing the opening refrain:

> The clouds appear at Guling
> And the sun turns round at Aoshan
>
> Joyfully we greet the immortals riding on rams
> Meeting the sacred birds high in the heavens
> To the elegant music the phoenix comes to dance
> More stirring than geese in flight is their beauty
> Graciously permit us to join the throng
> And bestow on us your generous blessings.

When this is finished the lead dancer and attendant dancers come forward and stand side by side. They kneel down and bow and then move back to their original positions. The lead dancer comes forward again and sings a song of praise to the emperor:

> Oh, as we sing and dance
> Expressing our congratulations
> We are trying to help
> Maintain the long, long blessings

We the women of the court were so moved

We know not what to do.

After this song the lead dancer returns to her original place. She then dances with the attendant dancers who have no implements in their hands, and they each turn once round to the left and facing north sing the two verses of the main song, "Byeongnyeonnonghyosa":

Verse 1

The dawn air is thick with blue mist and the sea is calm

The two or three mountain peaks by the river are cold

Jade pendants inside the robes

Send out an intriguing human scent

Red tags ride the rainbow of five-color clouds.

Verse 2

A clear omen are the full ears of rice

A smile and a blush soften the face

Looking upon the nine roofs of the palace

Looking up to the sky we pray three times

May you face Mt. Nanshan and live for a hundred thousand years.

After this song the lead dancer and attendant dancers each turn to the left three times. They stop and stand to face the north and sing the closing refrain:

In Three Spirit Mountain so far, far away

Day and night are divided after a hundred thousand years

In the spring breeze the legendary peach blossoms bloom

Casting a smile on the spring god of the east

A lucky wind brings fleeting fragrant motes

We pray you will live long and not grow old

As the auspicious smoke scatters and blue clouds disappear

Teasing the warm sunshine and whistling slowly.

At the end of the song the two pole bearers come forward and face the north, and as the lead dancer and attendants return to their original positions and stand in a row, the pole bearers sing the opening refrain:

How clear is the song of the departing crane

How intriguing the dance of the oriole

They shake their tags and say goodbye

Pointing to Three Spirit Mountain as they go

The sun sets red filling the air with the warmth of spring

From deep inside the white clouds comes the faraway sound of a crane

In front of the courtyard we bow twice

And following each other we duly leave.

When this is finished the lead dancer comes forward and sings the song of praise:

The rabble is gone and the world is clean

Showing gratitude for the virtue that brings peace to all

Suddenly depart the joyful scene for

The road to the ivory pavilion is far

We dare not do as we please

So we bow and await your commands.

(4) Pogurak: Ball Throwing Dance

Records indicate that Pogurak dates back to the time it was performed by 13 female entertainers in the 11th month of 1073, the 27th year of the reign of King Munjong of the Goryeo Dynasty, along

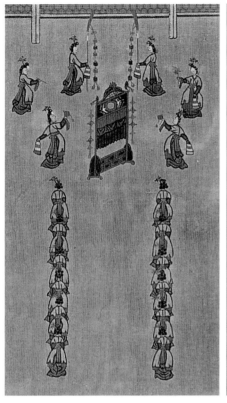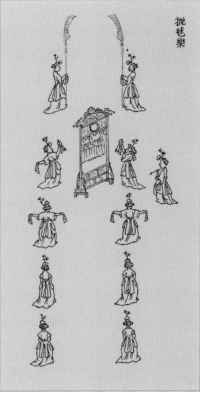

with another new court dance called Gujanggibyeolgi (Dance of Nine Skills).

During the Goryeo Dynasty, Pogurak was performed by female entertainers to the accompaniment of song on Dano Day (fifth day of the fifth month), and in the Joseon Dynasty, it was performed at Dano and also at court banquets.

In form, a gate-like structure with a hole in it (*pogumun*) is placed in the center of the stage and the dancers, divided into two columns, one to the left and one to the right, try to throw balls through the hole. If successful, the dancer is given a flower as a prize, and if not she is punished by having her face smeared with ink. Thus, Pogurak functioned as a type of court entertainment.

Regarding the origins of the dance, records state that a poet saw

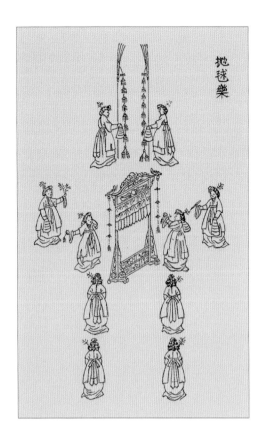

Fig. 19
Ball Throwing Dance
depicted in the *Royal
Protocol of the Banquet of
1868 (Mujin jinchan uigwe)*

in his dreams a pavilion in the middle of the water where court ladies were playing with a ball. Some argue that this was the beginning of Pogurak.

The dance features eighteen female dancers holding ceremonial implements standing in two columns, to the left and right of the performing space. Two pole bearers come forward while the gate is placed behind them. In the Joseon Dynasty, the dance was sometimes performed with only three or four dancers on either side of the gate.

The first dancer on the left comes forward to the gate and bows. When she rises a musician places a colored ball to the left in front of the gate. The dancer bends down to take the ball and dances, moving first toward and then away from the gate.

Each dancer takes her turn, first one from the left side and then one from the right side, and when they are all finished the pole bearers enter and sing the closing refrain. Then the two columns of dancers come forward and kneel down and bow. They rise, step back, and leave by the southern entrance.

(5) Yeonhwadaemu: Lotus Dance

Yeonhwadaemu originated in India and was introduced to Korea through Northern Wei in China. *Reference Compilation of Documents (Munheon bigo)* describes the dance as featuring two young female dancers dressed in beautiful clothes with gold bells in their hats that rattled as they moved. *Musical Canon of Joseon (Akhak gwebeom)* says it was performed with the Crane Dance (see description later) and also

in combination with the Dance of Cheoyong. That is, the Dance of Cheoyong was performed first, then a blue crane and a yellow crane appeared on stage and did the Crane Dance. A large lotus flower on a platform was installed at the back of the stage and when the cranes began to peck at the flower it opened up and two child dancers emerged and performed the Lotus Dance.

On its own, Yeonhwadaemu was performed at court rites held to expel evil spirits (*narye*). It has been designated Intangible Cultural Property No. 40 to ensure its preservation and transmission to posterity.

The dance proceeds as follows. A special wooden platform is placed at the southern end of the stage inside the throne hall. The platform is decorated with a beautiful vase and two large lotus blossoms. When the platform has been positioned, a musician leads out two young female dancers and seats them inside the flowers. The musician leaves and the blue crane and yellow crane enter and dance, moving toward the platform and pecking at the flowers. The flowers open up and two young dancers emerge from them and begin to perform the Lotus Dance. The dance starts with the two pole bearers coming slightly forward to sing the opening refrain:

> What a wonderful day selected for the brilliant feast
> Auspicious events of all kinds come all at once
> The lovely girls emerging from the lotus flower
> Present captivating dance and song with skill rare to see.

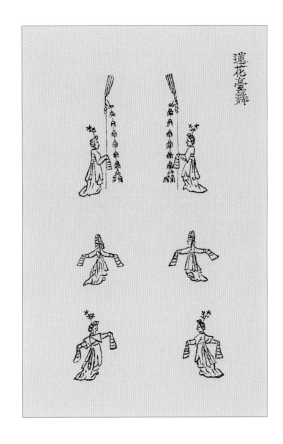

Fig. 20
Lotus Dance depicted in the *Royal Protocol of the Banquet of 1901* (*Sinchuk jinchan uigwe*)

When this is finished the pole bearers step back and face each other while the two girls from the lotus flowers come forward and sing a song titled "Misinsa":

From the Isle of Eternal Youth we descend born of the lotus
Deeply moved by the virtue of the king we come
To this flower to present the joy of song and dance.

After the song the young performers move forward and backward. They kneel down and pick up hats with bells attached and place them on each other's heads. A musician enters and ties the hat strings of each dancer and leaves. Then the dancers come slightly forward and sing the closing refrain:

The elegant music draws to an end
We bow before you and take leave of this brilliant place
We return to the carriage of the immortals
And head for the clouds far away.

After the song the two dancers step back, bow twice, and leave through the southern entrance.

B. NATIVE KOREAN COURT DANCE OF THE GORYEO DYNASTY

The Goryeo Dynasty had active cultural exchanges with other countries and many new court dances were created reflecting foreign influences. The foundations for classification of court dance were laid at this time when a distinction was made between dance of Chinese origin and dance of native origin.

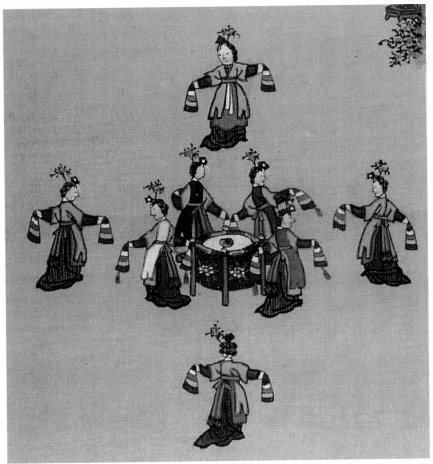

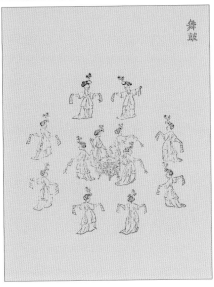

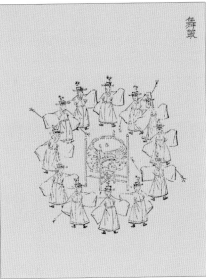

Fig. 21
Drum Dance from a folding
screen depicting a royal
banquet held in 1901

Fig. 22
Drum Dance depicted in
the *Royal Protocol of the
Banquet of 1901* (*Sinchuk
jinyeon uigwe*)

Fig. 23
Drum Dance depicted in
the *Royal Protocol of the
Banquet of 1829* (*Gichuk
jinchan uigwe*)

III. Court Dance of the Goryeo Dynasty • 61

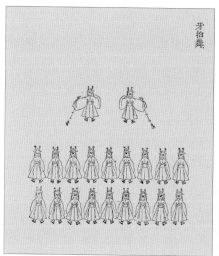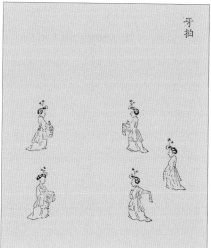

Fig. 24
Dong Dong depicted in the
*Royal Protocol of the
Banquet of 1828* (*Muja
jinjak uigwe*)

Fig. 25
Dong Dong depicted in the
*Royal Protocol of the
Banquet of 1829* (*Gichuk
jinchan uigwe*)

(1) Mugo: Drum Dance

The Drum Dance dates back to the time of King Chungnyeol (r. 1274-1308) of Goryeo, when a scholar official in exile picked up a piece of wood that had floated in from the sea and made a drum from it. Called *mugo*, it was small, like a Chinese drum, and was placed between two people who struck it as they danced around it.

The drum is said to have made a majestic sound and the performers dancing around it and striking it in turn were compared to butterflies circling a flower or a dragon flying up to heaven with a wish-granting bead (*cintamani*) in its mouth.

Whereas the Drum Dance was performed by two people in the Goryeo Dynasty, in the early Joseon Dynasty it was performed by two, four, or eight people. By the time of the reign of King Sunjo (r. 1800-1834), it had been revised in form to feature one large drum circled by four dancers and accompanied by eight attendant dancers. This is the Drum Dance version that has been handed down to the present.

(2) Dong Dong

First introduced to the Baekje Kingdom, Dong Dong was subsequently

accompanied by a song ("Dongdongsa") and transmitted to the Goryeo Dynasty. The song tells the sad love story of a fisherman. Until the 10th month of 1449 (31st year of King Sejong) the dance was performed under the name of Dongdongchum, but according to the *Musical Canon of Joseon* the name was eventually changed to Abakmu.

Abakmu was a dance performed with a small gourd-shaped instrument made of ivory. ("a" means "ivory" and "bak" means "gourd.") There are no elephants in Korea, but given that the gourd was made of ivory the dance was likely introduced from the regions west of China.

During the Goryeo period, the dance was performed by two female dancers. In Joseon it was modified to feature two or four dancers who struck the gourd once or three times as they moved forward and backward and turned. This is the form handed down to the present.

IV.
COURT DANCE OF
THE JOSEON DYNASTY

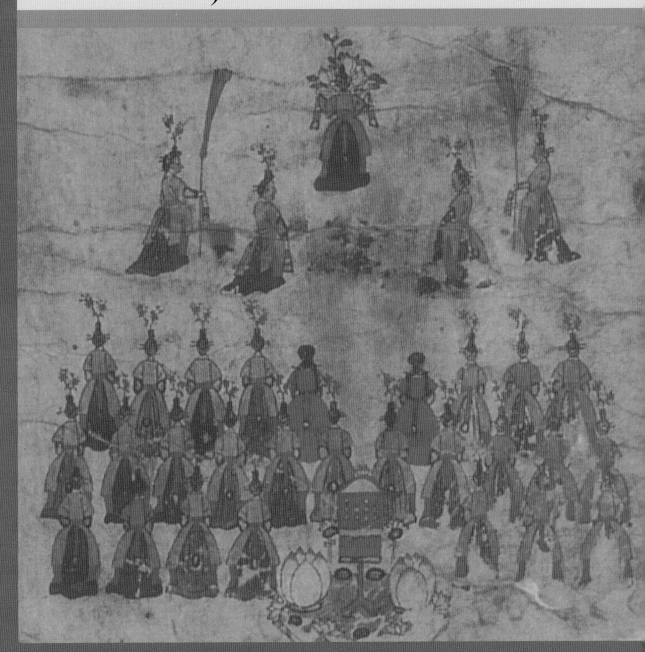

1. Historical Background

Yi Seong-gye, founder of the Joseon Dynasty (1392-1910), pursued a policy of suppression of Buddhism and promotion of Confucianism, resulting in the weakened influence of Buddhism and a rise in Confucian philosophy, culture, arts and customs. Two court offices in charge of music (A-akseo and Jeonakseo) were established based on the system of rites and music of China. These offices were also in charge of matters relating to dance.

The creation of native Korean court dance began in the early Joseon Dynasty. As Confucianism replaced Buddhism as the state ideology, dance came to be based not on Buddhist ideas of denial of the real world and finding salvation in the afterlife, but on the Confucian ideology of rites and music in pursuit of the establishment of a social order in real society.

Toward the late Joseon Dynasty, in line with the rise of Neo-Confucianism, court dance underwent various changes, influenced by the new school of practical thinking. Chinese-style court dance declined and native court dances that promoted Korean autonomy were newly created. During the reign of Sunjo, in particular, the form and content of traditional folk dance were introduced into court dance. Thus court dance, previously performed mainly for rites among the aristocratic class, developed in varied ways to become established as popular entertainment.

This in turn led to a greater level of artistry. Hence, the Neo-Confucian concept of good and bad of the early Joseon Dynasty, which was based on the aristocratic social order, was expanded to a more practical philosophy that promoted pursuit of the arts among ordinary people. This served as the catalyst for Joseon court dance to break away from Chinese-style artistry and develop its own unique characteristics.

2. Dances

Early Joseon Dynasty court music and dance was a development of court dance inherited from Silla and Goryeo. In the later Joseon period covering the reigns of King Yeongjo to Sunjo many dances were created, both Chinese-style and native dances, which are recorded in the *Musical Canon of Joseon* from the 17th century. They are also described in records of court dances compiled under the title *Jeongjae mudo holgi*, which gives a brief outline of all court dances performed in the later Joseon Dynasty, including the name of the dance, illustrations of the dance formations, the names and affiliated offices of the female and male dancers, the overall movements and musical accompaniment, and the content of the songs and chants. These *holgi*, or dance records, are valuable materials enabling the recreation of old court dances.

A. Court dance of the early Joseon Dynasty

1) Chinese-style court dance

(1) Geuncheonjeong: Dance of Praise to King Taejong

In his dreams King Taejong (r. 1400-1418), the third king of the Joseon Dynasty, visited the court of Ming Dynasty, China. The emperor and founder of Ming treated him with great propriety, and when Taejong returned to Korea the people sang and celebrated the occasion.

Prime Minister Ha Ryun recorded this event in a song titled "Geuncheonjeong":

> Praise our holy king
> Your virtue shines so bright
> So learned in letters
> So refined in prose
> The emperor's approval received

A whole nation joyful

As envoys of the lord king

It was not possible to delay

Meeting the emperor

Winning him over

His anger disappears

To the nation's great fortune

Our king thus honored

Followed the right path

And returned with duty fulfilled

Honor be to thy descendants

Our holy king pray receive

Our wishes for thy health and longevity

With the return of our king

Happiness reigns without end.

Prime Minister Ha Ryun presented this song to the court in the sixth month of 1402, the second year of the reign of Taejong. It was used for festivals as well as court dance, and during the time of King Sejong it was used for birthday rites and banquets held for senior citizens.

In the dance, eighteen female entertainers holding ceremonial implements stand in two columns, left and right. Two pole bearers and a scroll bearer stand in front, and behind them stand the lead dancer and one attendant dancer on the left. Behind them stand three dancers holding small parasols.

The two pole bearers come slightly forward and sing the opening refrain:

Bowing down to the Chinese court

Receiving the emperor's wonderful grace

Humbly the lord's royal writ is received

Enabling establishment of the nation
All the people are joyful and
Respectfully we offer this tribute.

After the song the two pole bearers step back to the left and right, and the lead dancer comes forward to sing the song of praise:

When Taejong was in the world of dreams
Cautiously he goes to the great country
And returns with the grace of the emperor upon him
All the people are joyful, young and old.
Together we sing and celebrate this auspicious event.

The major feature of this dance is Jiseonmu, which means "dance of the earthly immortals" and is a kind of improvised dance. The attendant on the right comes forward and dances with the lead dancer and then the two pole bearers come forward and sing the closing refrain.

(2) Sumyeongmyeong: Dance of the Wonderful Command

In his will the emperor of Ming Dynasty China presented King Taejong of the Joseon Dynasty with a seal and wishes for his happiness and longevity. To express the happiness of the aristocracy and the people on the occasion, Ha Ryun wrote the song titled "Sumyeongmyeong" (receiving the wonderful command):

Our diligent king
Virtuous and revered by all
Ruling the land like a filial son
There is no end to his high repute
With a mind of reverence

He serves the great nation with constancy

That resounds all over the world

To the benefit of our nation

The emperor gives a wonderful command

The golden seal shines

And what else did he grant?

A happy respected old age.

As the king bows and receives the command

The emperor is virtuous and wise

As the king bows and receives the command

There is honor for affairs of the land

Ah! Happy are we for our king

To receive the mandate of heaven

Protecting the people with humanity

May he live for a thousand years

Ah! Happy we are for our king

To lead with wit and a law so true

May it continue for ten thousand years.

In the sixth month of 1402, Prime Minister Ha Ryun presented those lyrics to the court and the dance that was set to this song was named "Sumyeongmyeong" also.

According to Volume 58 of *The Annals of King Sejong* (*Sejong sillok*), in the 10th month of 1432 (the 14th year of the reign of King Sejong), this dance was performed at court for birthday celebrations and at banquets for elderly citizens and foreign envoys.

In form, two pole bearers and one scroll bearer stand at the front. In the center is the lead dancer with four attendants on each side. Behind them are three dancers holding parasols and in a row from east to west stand eighteen dancers carrying ceremonial implements. The pole bearers and scroll bearer come slightly forward and sing the following

opening refrain:

> With a mind cautious and reverent
> All courtiers receive the command
> The lovely harmony of the music
> Resounds through all ears across the land.
> Jongmyo [royal shrine] and Sajik [altar to the gods of the earth and the harvest] shine brightly
> As the officials and people rejoice together

Afterward the lead dancer and attendants come forward and kneel down and bow. Then they rise and turn several times and when they return to their original positions, the lead dancer steps forward and sings this song of praise:

> A great work of propriety has Taejong achieved
> The emperor has given a bright command
> Granting the seal with good fortune and longevity
> The aristocrats rejoice and are moved with elation
> Competing with each other to sing.

The lead dancer then returns to her place and sings while bending forward and backward (*susumu*). Then the left and right attendant dancers face each other, turn back to back, and face north. They raise their hands and cross them as they lower them again (*palsumu*) while turning around, and then return to their original places. The pole bearers come in and sing the closing refrain:

> Ascending the throne for the first time
> Is truly a state of endless beauty
> What more is there left to say?

We sing and we dance

We rejoice and hold rites

And pray for the longevity of our king.

In the 10th month of 1402, the court office of music (Jeonakseo), devised a dance for this poem and named it Geumcheongmu. The dance honors the achievements of Taejo in founding the Joseon Dynasty and was performed at court banquets while the aforementioned verses were sung. It has been handed down in this form to the present.

The dance begins with eighteen female dancers holding ceremonial implements and standing in two columns, left and right. In front stand a scroll bearer and two pole bearers, and behind them are two columns of six dancers each. In the middle stands a dancer holding a golden ruler and behind her four dancers with parasols. The scroll bearers and pole bearers come slightly forward and sing the following opening refrain:

Upholding the sacredness and wonder of the omen

The king is beautiful in his virtuousness

Pray grant generosity in forgiveness

And with this feast give us faith it what we extol.

After this song the two pole bearers move back to either side. The dancers come forward to form two columns of six, one on either side of the scroll bearer. Then the dancers with the golden ruler and the yellow parasols come forward and stand beside the two lines, and the bearer of the golden ruler sings the following song of praise:

To dream of the golden ruler is to receive the mandate of heaven

In Taejo's dreams a celestial being descended from heaven

And presented a golden ruler, saying

"Gyeong Sijung [Gyeong Bok-heung] is a moral man but too old

Choi Samsa [Choi Yeong] is renowned for honesty but is said to be foolish

But you Taejo are wise in literary and military arts, virtue and knowledge

In you the people trust,"

And gave him the golden ruler.

This song is followed by "Geumcheoksa," Jeong Do-jeon's poem set to music. Then the two pole bearers enter and sing the closing refrain:

The music has been played nine times

Prayers offered for the longevity of the king

Before the merriment reaches its height

Minds must quickly be turned to caution

We bow, say farewell and return

Pray rest in comfort.

(4) Haseongmyeong: Dance of Good Tidings

In Volume 6 of the *Annals of King Sejong*, the entry for the 26th day of the 12th month records that under royal command the scholar-official Byeon Gye-ryang wrote the verse "Haseongmyeongsa," which heralds good fortune. It was then set to music and dance for court banquets, especially for the entertainment of foreign envoys.

In the fourth month of the second year of Sejong's rule it is said that an envoy, taking part in a banquet, requested to be given the poem which he had seen written on a scroll. In addition, according to the *Expanded Reference Compilation of Documents*, the benevolent rule of the king moved heaven to send stability and good fortune to the nation. All the people rejoiced and were moved to dance and write poetry, which was set to music and dance to praise the rule of the king.

"Haseongmyeongsa" by Byeon Gye-ryang

1.

The virtue of the emperor

Makes even the heavens bright

Heaven sends down sweet dew

Covering the land with propriety

The water becomes clear and the turtle appears

And the lotus pond shines beautifully

An omen appears on the golden water

With an array of blessed signs

Auspicious clouds of five colors

Are thick and fluffy and bright

The exquisite scenery

Brings a divine response

The omens appeared

One after another

All the people and ministers bow

Praying for the longevity of the emperor.

2.

The great benevolence of the emperor

Fills the people with satisfaction

Even the birds and animals are at peace

The light of the omen reaches everywhere

Ah! That mythical spotted beast

And the overweight *kylin* [mythical animal]

And a swan unmistakable

Auspicious birds and beasts ever so mild

Even the lion appears

To bring good fortune aplenty

White pheasant and black rabbit

Things which are rare in this world

Congratulations come from all around

Humbly, lest we forget

All ministers and the people bow

And pray for the longevity of the emperor.

This dance is performed by eighteen female dancers holding ceremonial implements standing in two columns, left and right. A scroll bearer and two pole bearers stand at the front. Behind them stand six dancers in two lines of three, one line on each side. And at the back stand four dancers holding parasols. The scroll bearer and pole bearers come forward and sing this opening refrain:

Holy God rules heaven and earth

Sending peaceful energy far and wide

Presenting omens in heaven and on earth

All good fortune comes to pass

Unable to contain our great joy

We offer these words of congratulations.

The scroll bearer and pole bearers move back and the two lines of dancers come forward, kneel down and bow, then return to their positions. Then the scroll bearer comes forward alone and sings the song of praise:

1.

Haseongmyeong is to sing of auspicious signs

As soon as your majesty rose to the throne

All under heaven was peaceful as fortune rained down.

2.

We people of the east rejoice and dance in happiness

We write this poem and offer it up as an omen

Revealing our heartfelt congratulations.

When the song is finished the scroll bearer moves back. The dancers do the improvisational dance of the earthly immortals in turn and then all of them together dance in two circles going in opposite directions, the dancers in one circle facing outward and those in the other circle facing inward, and return to their original positions. The two pole bearers come out and sing the closing refrain:

Singing and dancing we extol

Divine virtue of a kind never seen before

May your majesty enjoy health

Longevity and the blessings of heaven

The sound of the music draws to an end

We bow twice and declare our departure.

(5) Seongtaek: Dance of Sacred Beneficence

An entry in Volume 40 of the *Annals of King Sejong* says that in the fifth month of 1428 (10th year of the reign of King Sejong) Seongtaek was created to be performed at a banquet to praise the virtue of the emperor and entertain Chinese envoys who had crossed rough seas and rocky mountains on their way to Joseon. It was performed to the following song:

1.

Ah! The divine virtue of the emperor

Spreads contentment all round

All nations under heaven

Crossed rough seas and mountains

Our nation from the time

Of preceding kings

Has fulfilled the duties of a tributary state

Obeyed the law of the emperor

Our judicious king has

Faithfully followed his will

Respectful and devoted to the last

He receives the grace of the benevolent emperor.

2.

The carriage of the envoys comes

Speeding over waters and mountains

From the seat of the emperor

To reach a faraway land

Our king goes out to meet them

As if greeting the emperor himself

Our king bows with lowered head

Praying for the emperor's longevity

The great devotion of the king

The divine virtue of the emperor

Are in complete understanding

May joyful times continue without end.

This dance is performed by eighteen female dancers divided into two columns, one to the left and one to the right. A scroll bearer and two pole bearers stand at the front and behind them four dancers on each side. In the middle stands the lead dancer and behind her three dancers holding parasols. The scroll bearer and pole bearers come forward slightly and sing the opening refrain:

The influence of His Majesty's virtue

Extends far and wide to the outskirts

The people in faraway provinces

Have an irrepressible urge to dance and jump

Pray permit us to join the throng

And look upon his achievements forever.

After this song the two pole bearers move back and the lead dancer moves forward with four dancers from the left and four from the right. They kneel down and bow, then return to their places. The lead dancer then comes alone to the front and sings this song of praise:

Seongtaek is entertainment for the envoys at court

Entertaining the envoys is to pay reverence to the emperor

Your Majesty has realized a great achievement

Estimable in the eyes of the emperor

So the special envoys come and the people sing for joy.

After the song the lead dancer dances with the two attendant dancers. Then the two pole bearers enter and sing the closing refrain.

Content with the favor created

The king takes all pains to offer his duty of consolation

So deeply moved

We offer this benediction.

As the music now draws to a close

We bow, and stepping back announce our departure.

(6) Suborok: Dance of the Precious Epistle

Before Yi Seong-gye (Taejo) ascended the throne in 1392, an immortal appeared from a cliff of Mt. Jirisan in Jeollabuk-do Province

and gave him an auspicious epistle foretelling that he would be king. The scholar-official Jeong Do-jeon composed a poem about this episode titled "Suboroksa," and in 1393, the second year of the reign of Taejo, a dance called Suborok was created to be performed to the words of the poem. During the reign of Jeongjo (r. 1776-1800), it was not only performed in the eighth and ninth months at royal banquets for the elderly but was often performed at court ceremonies.

"Suboroksa" by Jeong Do-jeon

1.

That high mountain

Is a stone wall that reaches to heaven

Breaking the stone

And receiving the rare epistle

Gallant Yi Taejo

Will rise up and seize the day

But who will help him?

The virtuous man named Jo Jun.

2.

The noble man named Baek Geuk-ryeom

Is coming from Geumseong

With the help of the three Jeong

He will achieve

Foundation of a new capital

To last 800 years

As an omen received by His Majesty

It is called the precious epistle.

This dance features one scroll bearer and two pole bearers standing at the front, side by side, with eighteen dancers holding ceremonial

implements standing behind them in two columns of nine, one to the left and one to the right. In between the two groups stands one dancer holding the precious epistle, and behind the two groups are two dancers representing the earthly immortals, one on each side. The scroll bearer and two pole bearers step slightly forward and sing the opening refrain:

> The precious epistle from heaven has been received
> Opening the glorious and lasting fate of the nation
> All the people rejoice together
> And offer up their praise.

The two pole bearers then step back, one to each side, while the bearer of the precious epistle comes forward and hands it to one of the king's secretaries and then kneels down and bows. Then holding up the right hand the dancer rises and sings this song of praise:

> Receiving the Suborok is obtaining the precious epistle
> In Taejo's dream an unknown person took the epistle
> From the Jirisan cliff and handed it to him
> In the year of Imsin [1392] the omen came true
> And thus Suborok was created.

The lead dancer then steps back and other dancers representing the earthly immortals from the left and right come forward into the center from the left and right and dance while singing "Suboroksa" (Poem of the Precious Epistle).

The lines of nine dancers carrying ceremonial implements come from each side to form two circles, one facing outward and the other facing inward, and move round the circle three times. When they return to their original positions and stop, the earthly immortals come forward,

face each other, then turn back to back, and return to their original positions. Then the two pole bearers enter and sing the closing refrain:

> Nine kinds of songs have been played and come to an end
> With prayers for a thousand years and into eternity
> Fortunately it is an age of peace
> We dare to express our joyous hearts
> And bow as we leave this brilliant scene
> May you rest happily in peace.

All the dancers then step back and leave through the southern entrance.

(7) Hahwangeun: Dance of receiving the Benevolence of the Emperor

When King Sejong received recognition as king from the emperor of Ming Dynasty China, the scholar-official Byeon Gye-ryang was commanded to write a congratulatory poem commemorating the event. This poem was titled "Hahwangeunsa," or "Poem of Receiving the Benevolence of the Emperor."

"Hahwangeunsa" by Byeon Gye-ryang

1.
Our brilliant founding father
Founded this nation of ours
Handed to his descendants
Good kings from generation to generation
That precious visage
With wisdom inbred
Filial and respectful
Benign and sincere
Learned in Neo-Confucianism

Constantly working

The son knows the will

Of the enlightened king

And so he is entrusted

To take care of the nation.

2.

The permission of the emperor granted

The wonderful edict is bestowed

His Majesty bows down his head

Truly divine is the emperor

Because the emperor is divine

His benevolence reaches to Joseon

And all the people and ministers dance

Gratitude fills heaven and earth

May Jongmyo [royal shrine] and Sajik [altar to the gods

of the earth and harvest]

Endure for tens of thousands of years.

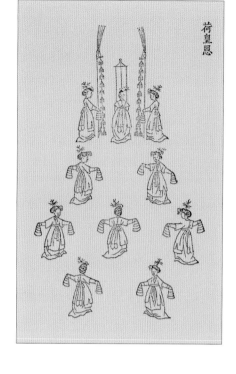

A dance called Hahwangeun was created to accompany the poem. It was originally performed at banquets for foreign envoys but in the latter half of the Joseon Dynasty it was often performed at all kinds of court ceremonies.

In formation, eighteen dancers holding ceremonial implements stand on the left and right sides. In front of them stand a scroll bearer and two pole bearers with three dancers behind each on the left and right. The lead dancer stands in the middle behind the scroll bearer, and behind her stand three dancers carrying parasols. The scroll bearer and two pole bearers step slightly forward and the pole bearers sing the opening refrain:

Receiving the special grace of the emperor

The throne was put to right

We sing of the great virtue of our king

May his grace spread far and wide

We dare to look at the face of our king

And offer up this song.

Then the pole bearers step back and stand on the left and right, respectively, and the lead dancer comes forward to sing the song of praise:

Hahwangeun means receiving the divine edict of the emperor

In the name of the emperor the king carries out affairs of state

Upholding the will of the emperor the people rejoice

And create this dance Hahwangeun.

After this song the lead dancer steps back and returns to her place. With six dancers from each side she sings the poem written by Byeon Gye-ryang while bending forward and rising up again. Next, the lead dancer stands in the center and dances while the others on the left and right create a square, two in the north, one in the east, one in the west, and two in the south. When the lead dancer moves to face the two dancers in the north they turn around and dance together before she moves on to the two dancers in the east and south, and then the two in the west and south. Then she returns to her original position and the two pole bearers enter to sing the closing refrain:

Feasting and making merry

Propriety reigns with satisfaction

Thriving and prosperous

We pray this lasts for eternity

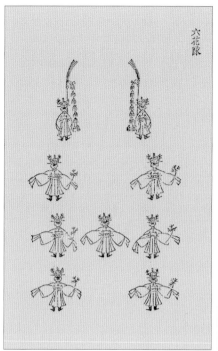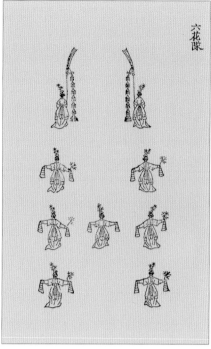

Fig. 29
Dance of Six Flowers
depicted in the *Royal
Protocol of the Banquet of
1901* (*Sinchuk jinyeon
uigwe*)

Fig. 30
Dance of Six Flowers
depicted in the *Royal
Protocol of the Banquet of
1902* (*Imin jinyeon uigwe*)

As the music draws to an end

We bow and announcing our departure we leave.

After the song the two pole bearers and the scroll bearer step back, and the dancers come forward to kneel down and bow. They rise, step back and leave through the southern entrance.

(8) Yukhwadae: Dance of Six Flowers

In China, dances featuring performers with flowers in their hands were created after the Tang and Song dynasties. Yukhwadae, featuring flowers of six different colors, was one of several dances based on such Chinese flower dances created after the reign of King Sejong.

In the early Joseon Dynasty, the formation of this dance comprised two pole bearers at the front, and behind them three dancers on the right dressed in dark blue and carrying dark blue flowers in one hand,

and three dancers on the left dressed in red and carrying red flowers. In the middle stood a lead dancer and at the back four dancers carrying parasols. To the east and west eighteen dancers carrying ceremonial implements stood in two columns.

In the latter Joseon Dynasty, the three dancers on the left were dressed in jade, purple, and dark blue, and those on the right in green, crimson, and pink. The lead dancer in the center was dressed in yellow. First the two pole bearers would come forward and sing this opening refrain:

> With a new flower in our hands
> We delight in the beautiful spring light
> Jeweled belts around our waists
> The full yard is covered in silk
> Happily the musicians in the yard take part
> So pray tell the reason for being at this feast.

When the song is finished the two pole bearers step back to the left and right, respectively, and the lead dancer sings a response:

> The tune of the love song is beautiful
> Certainly not of the world that we know
> The lyrics of the peach leaves are tender
> And not for the common man's ears.

After this song the rest of the dancers come forward one by one to take their turns at singing. They end up forming a big circle and returning to their original positions as the two pole bearers enter to sing the closing refrain:

> Green leaves and beautiful flowers
> Show off their grace in the lovely scenery

Lucid song and exquisite dance

Such talent revealed in this illustrious event

As the elegant music draws to a close

We bow and take our leave

(9) Gokpa: Dance with Vocal Accompaniment

Gokpa is derived from one of the *daqu* (literally "big songs") of Song Dynasty China. There is no description of the dance in the records of rites in *The History of Goryeo*; only the lyrics of the accompanying song remain.

Records from the ninth month of 1425, the seventh year of the reign of King Sejong, show that Gokpa, which had not been performed for a long time and was in danger of disappearing, was restored that year. It is believed that Gokpa was introduced during the earlier Goryeo period when the music and dance of female entertainers was introduced from China, but was not performed very often.

In this dance two pole bearers stand at the front with two attendant dancers on the left and right, respectively. The pole bearers come forward and sing the opening refrain:

The sound of music rings in the beautiful scenery

The young girls are dancing all over the fragrant fields

Envious of their lovely appearance

Dancing and fluttering together

With permission to join the throng

May you enjoy the spectacle.

After the song the two pole bearers move to the back and two attendant dancers come forward to sing the two verses of the main song:

1.

Spring comes early to the imperial capital

The ice has thawed on the palace hills

The east wind blows fresh and warm

[...]

2.

No soldiers are needed, the prince is in control

Surrounded by beautiful scenery

The virtue of past kings reaches us here.

When the song is finished the dancers move to the back and come forward again and face each other, turn back to back and then face north. They dance forward and backward twice and then the pole bearers enter and sing the closing refrain:

Seven intriguing dances we have shown

With the wonderful skill of flying swallows

Two or three verses of clear song

Expectant of beauty like a string of crystal beads

The five tones are sent off together

And the six notes chase each other

In the courtyard we bow twice

And leading each other we take leave.

2) NATIVE KOREAN COURT DANCE

(1) Ilmu: Ritual Line Dance for the Royal Ancestral Rites

Ilmu originated in Zhou Dynasty China (1045 BCE-256 BCE) and the name literally means "line dance." It was introduced to Korea in the form of thirty-six dancers in six rows of six during the reign of King Yejong of Goryeo when the ritual music of ancient China was imported

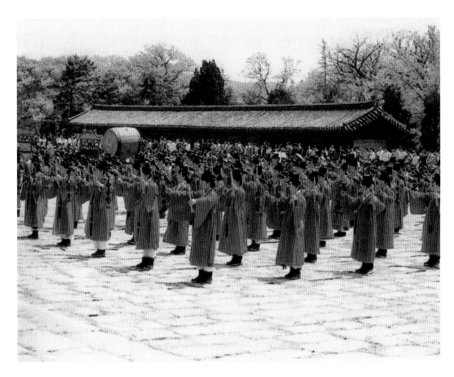

Fig. 31
Line Dance from Jongmyo Jeryeak, the music and dance performed as part of the rites at Jongmyo, the royal shrine of the Joseon Dynasty

from the Song Dynasty (960-1279). In 1447 (29th year of King Sejong) during the Joseon Dynasty, it was performed for ritual purposes. Some changes were made in 1465 under the command of King Sejo, after which it was performed as part of the ancestral rites at the royal shrine, Jongmyo, when the king personally performed a sacred rite in honor of his ancestors. Ilmu was also performed at rites honoring Confucius at the national Confucian shrine, Munmyo. Unlike other court dances, Ilmu was not performed at the royal palace for entertainment.

Ilmu is composed of two dances: Botaepyeongmu, which is a civil dance (*munmu*) to honor literary and scholarly achievements, and Jeongdaeopmu, which is a military dance (*mumu*) to praise military feats. *Mubo*, records of dance from the Joseon Dynasty, show that in 1897 Ilmu performances featured eight rows of eight dancers, but after 1910 the original six rows of six dancers was revived.

In China, Ilmu was performed by different numbers of dancers for

different rites. In rites for emperors it was performed by sixty-four dancers in eight rows of eight, for queens by thirty-six dancers in six rows of six, and for Confucian scholars and high officials by sixteen dancers in four rows of four. As Joseon was considered a tributary state of China, when Ilmu was performed in Joseon it usually involved thirty-six dancers.

The civil dance was performed at several stages in the ritual, for instance, greeting the spirits, making offerings, and the king's first offering of wine, while the military dance was performed at the second offering of wine and the final offering.

At the national Confucian shrine, the civil dance was performed by dancers holding a flute in their right hands and a pheasant feather in their left, symbolizing peace. The military dance was performed by dancers holding a shield in their right hands and an axe in their left, symbolizing war. The civil dance was performed in a similar way at the royal ancestral rites, whereas the military dance was performed with dancers in the first three rows carrying swords and dancers in the last three rows carrying spears.

The music and movements of Korean Ilmu were created during the reign of King Sejong and were revised during the reign of Sejo. The dance is described in the *Record of the Dance of Jongmyo* (*Siyong mubo*), thought to date to King Yeongjo's reign. It has been handed down to the present and continues to be performed once a year at the royal shrine, Jongmyo, on the first Sunday of May, by the descendants of the Yi royal family of Joseon.

(2) Bongnaeui: Dance Welcoming the Phoenix

In the fourth month of 1445 (27th year of the reign of King Sejong), the king composed "Yongbi eocheon-ga" ("Songs of the Flying Dragons"), a paean comprising 125 stanzas praising the achievements of Yi Seong-gye (Taejo), founder of the Joseon Dynasty. Bongnaeui is

the dance performed to the words of this paean.

Bongnaeui is actually a suite of two dances: Geumcheongmu, which depicts Yi Seong-gye receiving a divine message at Mt. Manisan; and Suborok (described previously), which depicts Yi Seong-gye receiving a precious epistle from an immortal at Mt. Jirisan. Bongnaeui was created to pass on to future generations the lofty spirit of Yi Seong-gye, who founded Joseon in accordance with omens from the gods of heaven and earth.

The dance is performed in the following configuration: eighteen dancers holding ceremonial implements and female dancers carrying various kinds of musical instruments, such as *wolgeum* (4-string long-necked lute), *dangbipa* (4-string Chinese lute), *hyangbipa* (5-string Korean lute), *hyangpiri* (cylindrical oboe), *daegeum* (large bamboo transverse flute), and *janggo* (hourglass drum), stand in lines on the right and left sides; two pole bearers stand at the front and four female dancers behind them in two lines, left and right, respectively; and at the back stand four female dancers holding parasols. The two pole bearers step forward and sing the opening refrain:

> On reflection, our country has received a great mandate
> From heaven promising prosperity for the nation
> His Majesty will make the nation prosperous through all eternity
> So we chant and sing this song of praise.

After this song the eight dancers on both sides perform various movements and songs. Then the four dancers from the left side form a circle facing west, and the four dancers from the right side form a circle facing east. They move around the circle in opposite directions and return to their original positions. Next the dancers on both sides sing and dance facing each other, then turn back to back, and then face north. Then they form one big circle and return to their original positions. The

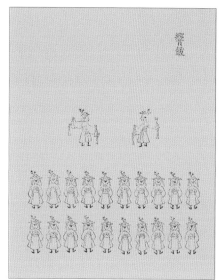

Fig. 32
Castanet Dance depicted in
the *Royal Protocol of the
Banquet of 1829* (*Gichuk
jinchan uigwe*)

Fig. 33
Castanet Dance from a
folding screen depicting a
royal banquet held in 1848

two pole bearers appear again and sing the closing refrain:

The king's virtues so lofty and firm

Are difficult to describe

Hence we give shape to them in lyrics and song

[…]

(3) Hyangbalmu: Castanet Dance

Hyangbalmu is a dance that was invented during the Joseon Dynasty based on Chinese court music from the Tang Dynasty. Female entertainers (singers and dancers) hold *hyangbal*, instruments similar to castanets but made of metal, with their thumb and middle finger of both hands. They click the *hyangbal* two or three times in time with the music. Eight dancers step forward side by side and kneel down and bow. Then they rise and sing the following song:

The dawn sky is covered in thick blue fog

Gentle waves roll on the sea and by the river

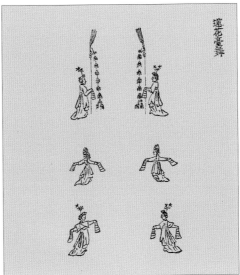

Fig. 34
Crane Dance depicted in the *Royal Protocol of the Banquet of 1902* (*Imin jinyeon uigwe*)

Fig. 35
At the end of the Crane Dance, the cranes peck at the lotus flowers on the platform and dancers emerge from the flowers to perform the Lotus Dance.

The mountain peaks are cold

[...]

(4) Hangmu: Crane Dance

The Crane Dance, called Hangmu, is the only form of bird dance in Korea. In the early Joseon Dynasty it featured two dancers, a blue crane and a white crane. In terms of the yin-yang theory, blue symbolizes the east and white the west. In the latter part of the Joseon Dynasty, the Crane Dance featured a blue crane and a yellow crane.

The Crane Dance formed part of a composite performance called Hak-yeonhwadae-cheoyong-hapseol, which combines the Crane Dance, the Lotus Flower Dance and the Dance of Cheoyong. It was performed on the evening of the 30th day of the 12th month after the court rites called *narye*, which are aimed at dispelling evil spirits from the royal palace. In the latter part of the Joseon Dynasty, the Crane Dance and Lotus Dance were sometimes performed together and sometimes separately at court banquets. Today, the crane and lotus dance combination, called Hak-yeonhwadaemu, has been designated

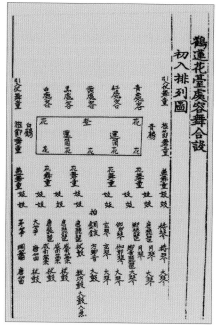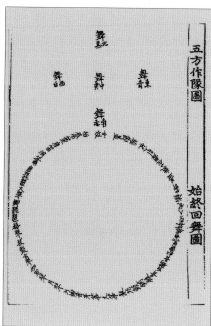

Fig. 36
Dance diagrams for the Combined Crane, Lotus, and Cheoyong Dance from the *Musical Canon of Joseon* (*Akhak gwebeom*)

Important Intangible Cultural Property No. 40 for its succession and preservation.

(5) Hak-yeonhwadae-cheoyong-hapseol: Combined Crane, Lotus, and Cheoyong Dance

Cheoyongmu, the Dance of Cheoyong (described previously), originated from the tale about a son of the Dragon God named Cheoyong in the time of King Heongang, the 49th king of Silla. It was performed by a solo dancer wearing a black monk's robe and black gauze cap until the time of King Chunghye of Goryeo (r. 1339-1344). Later King Sejong of the Joseon Dynasty ordered lyrics to be composed for a new version of Cheoyongmu, which featured one dancer in each of the five directions (the four cardinal points and the center). The lyrics were sung to the music of "Bonghwangeum" ("Tune of the Phoenix"). Cheoyongmu was performed twice after the *narye* rites. The first performance featured Cheoyongmu on its own, without the Crane

and Lotus Dance. The second performance included both the Crane and Lotus Dance followed by the singing of Buddhist hymns as the dancers moved in a big circle.

(6) Gyobang Gayo: Processional Dance

Gyobang Gayo is not the name of a separate dance as such but the term used in reference to any dance performance that accompanied the king's procession back to court after traveling outside the palace. For the royal procession, a movable stage was set up with a mountain made out of wooden boards and a platform with flower-patterned woven mats was placed in front of the stage. A box containing incense and prayer papers was placed on tables set up on the right and left sides of the stage, respectively, with a female court dancer standing to the left and right of each table.

Fig. 37
Dance diagram for a processional dance from the *Musical Canon of Joseon* (*Akhak gwebeom*)

When the royal palanquin approached, the royal band stood on the left and right sides and a group of female entertainers standing behind them began playing and singing a court song called "Yeominnak."

In addition, when the box of incense and prayer papers was offered to the king, the Crane Dance and Lotus Dance were performed as well as a variety of other court dances as a rite to welcome the king back to the court.

(7) Mundeokgok: Song of Literary Virtue

In the seventh month of the second year of King Taejo's reign, the scholar-official Jeong Do-jeon composed poems and songs to praise the literary and military achievements of the founding monarch of Joseon. A dance named Mundeokgok was performed to the poems and songs.

Mundeokgok begins with a solo dance. When the dancer retreats,

four other dancers come forward and perform and when they retreat they are followed by another four dancers, and when they retreat they are followed by the final four dancers. In other words, Mundeokgok is performed by twelve dancers in all.

B. Court Dances Created in the Latter Half of the Joseon Dynasty

1) Chinese-style Court Dance

Four court dances following the form and style of dances imported from the Tang Dynasty were newly created in 1829 (the 29th year of the reign of King Sunjo): Jangsaengboyeonjimu, Yeonbaekbokjimu, Jesuchang, and Choehwamu.

(1) Jangsaengboyeonjimu: Dance of Longevity

In 1829, the 29th year of the reign of King Sunjo, Crown Prince Hyomyeong invented the dance Jangsaengboyeonjimu, imitating a performance from China's Song Dynasty. A reference to the original Song dance is found in *The Complete Classics Collection of Ancient China* (*Gogeum doseo jibseong*), which states that it was the seventh of twenty-eight pieces of court banquet music that were performed during the Song Dynasty.

Some revisions and improvements were made to Jangsaengboyeonjimu in 1887. As a result, it was performed with two pole bearers standing in the front and dancers dressed in blue, red, yellow, white and black standing in the four directions and the center, respectively. Stepping forward the two pole bearers sing the opening refrain:

> A long and lovely day in spring
> A grand banquet is held at the royal court
> Auspicious clouds hover in the sky

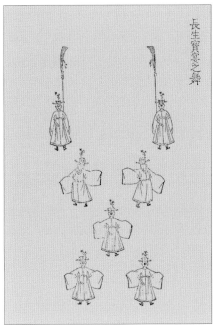
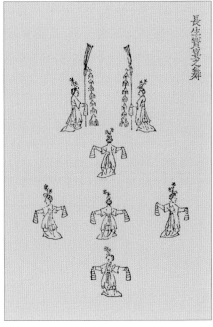

Fig. 38
Dance of Longevity
depicted in the *Royal
Protocol of the Banquet of
1892 (Imjin jinchan uigwe)*

Fig. 39
Dance of Longevity
depicted in the *Royal
Protocol of the Banquet of
1902 (Imin jinyeon uigwe)*

The music of the spheres resounds
We hold an audience with His Majesty and sing this song.

After the song one pole bearer moves to the left side and the other to the right, and the lead dancer in the center and the other four dancers step forward and kneel down and bow. The lead dancer then moves forward and sings this song of praise:

His Honorable Majesty
Possesses benevolence and displays unchanging virtue
Blessings so great are without end
A reign of peace will be enjoyed
[…]

After returning to her original position, the lead dancer and four attendant dancers sing as they dance. Then the two pole bearers enter

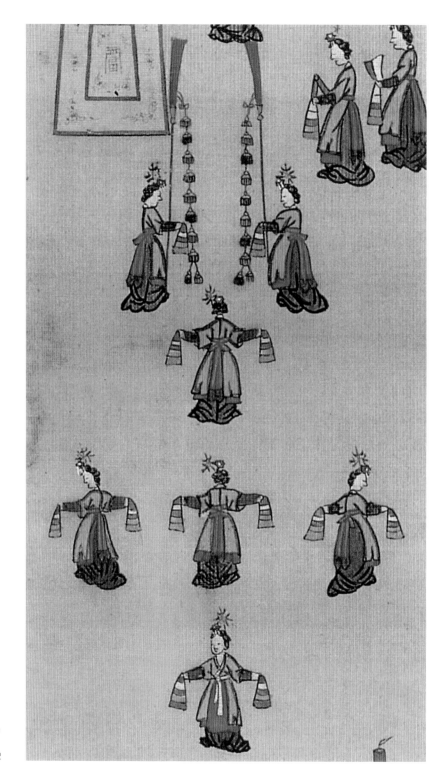

and sing the closing refrain:

> At this lavish banquet all kinds of dances have been performed
> Nine pieces of music have been played on jade flutes, harps and lutes
> We bow twice in the front yard and following each other we leave.

(2) Yeonbaekbokjimu: Dance Enumerating All Sorts of Blessings

Created in 1829, the 29th year of the reign of King Sunjo (r. 1800-1834), Yeonbaekbokjimu (Dance Enumerating All Sorts of Blessings) is a Korean version of a song of praise of peaceful days under the reign of King Yao created by an old farmer in Kangqu, China. It was revised in 1887 during the reign of King Gojong (r. 1863-1907).

The dance is performed by seven dancers. There are two pole bearers in the foreground, who function mainly as ushers, and five dancers at the back, dressed in blue, red, yellow, black and white, respectively. Reciting verses from the song "Taepyeong Yeonwolsa" ("Song of a Peaceful Era"), the dancers stand in a big square with one person in the center, and then turn around in one big circle. The dance begins with the pole bearers coming forward and singing the opening refrain:

> We descended from heaven to the palace of a sage
> To bestow all sorts of endless blessings
> To offer a dance extolling peace in this time
> We dare to have an audience with the king and present this song.

The pole bearers retreat, one to the left and one to the right. The five dancers at the back move forward and bow while the lead dancer in the center steps forward and sings the song of praise:

> Our dear king influences the people by abundant virtuous examples
> Hence he enjoys three blessings, longevity, wealth and fertility

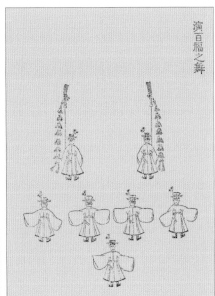

May the king enjoy good fortune and a long life

To celebrate this auspicious banquet

Words of benediction are offered

And a song inviting all blessings.

The lead dancer in the center dances with each of the others in turn and the five dancers sing "Haedong geumilsa" ("On This Day East of the Sea"):

On such a peaceful day as today east of the sea [Korea]

The auspicious sun and clouds brighten this magnificent occasion

The mother immortal offers the peach of immortality from the fairy pond

To celebrate eternal youth, never growing old even after eight thousand years.

The two pole bearers join the rest of the dancers and sing the following song:

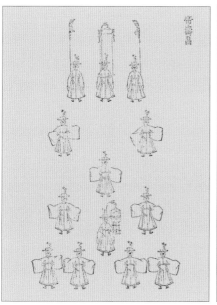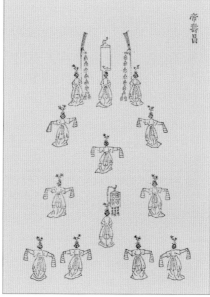

Fig. 43
Dance for the Emperor's
Longevity and Prosperity
depicted in the *Royal
Protocol of the Banquet of
1829 (Gichuk jinchan
uigwe)*

Fig. 44
Dance for the Emperor's
Longevity and Prosperity
depicted in the *Royal
Protocol of the Banquet of
1902 (Imin jinyeon uigwe)*

Having finished music performances
We heavenly fairies announce our departure
Bowing twice at the steps of stone
Following each other, we are about to leave.

The pole bearers step backward and the lead dancer advances to sing the song of praise:

Rising sounds of congratulations suggest
It is an era of tranquility
Return from the roads to three peaks
For the eternity of posterity.

(3) Jesuchang: Dance for the Emperor's Longevity and Prosperity

Originally performed for the emperor on his birthday in Song Dynasty China, Jesuchang (Song for the Emperor's Longevity and Prosperity) was recreated in the Joseon Dynasty as a congratulatory dance of the

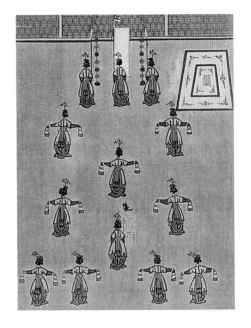

Fig. 45
Dance for the Emperor's
Longevity and Prosperity
from a folding screen
depicting a royal banquet
held in 1901

same title by Crown Prince Hyomyeong in 1829 (the 29th year of the reign of King Sunjo).

Jesuchang is performed by three groups of dancers: two pole bearers and a standard bearer in the front; five dancers with four attendant dancers standing in a square formation relating to the four directions, and a lead dancer in the center; and, five dancers standing in a row at the back, with one holding a yellow parasol. To start, the pole bearers come forward and sing this opening refrain:

> Thanks to the virtue of the king the people live in harmony
> There is the auspicious sign of a clear Yellow River
> The king leads a long, healthy life
> So anxious to extol the virtues of the king, the person of distinction
> We dare to have an audience with the king and deliver a eulogy.

The four attendant dancers advance and kneel down to bow. The lead dancer moves forward and sings the song of praise:

> Jesuchang lavishes praise on the king for his honest virtue
> On reflection, the virtue of His Majesty
> Brightens the whole world
> He is like heaven reigning over all things
> And all nature on earth
> As such the nation flourishes and is in peace
> The weather is always mild and the sun and moon are bright
> Hence we offer a song for his health and longevity.

The lead dancer dances with each of the attendants in turn. The

dancers form two groups and move around in two circles, one facing inward and the other facing outward, and return to their original positions. The pole bearers enter and sing the closing refrain:

> The musical performance has ended
> We pray for the king's longevity
> Marking this pleasant feast in a peaceful reign
> We are pleased to felicitate the king
> We bow and take leave of this brilliant feast
> May you rest in comfort.

(4) Choehwamu: Dance in Praise of Spring Flowers

Based on the line "urging flowers to bloom" in "Xiao Shi Tiao" (literally "small stone music") composed by Emperor Taizong of Song Dynasty China, Choehwamu was created by Crown Prince Hyomyeong in 1829 (the 29th year of the reign of King Sunjo). The pole bearers move forward and sing the opening refrain:

> The beautiful song of orioles is heard in the palace
> Teasing spring to come to the capital
> The beats of the drum
> Urge flowers in the palace garden to bloom
> Coming attracted by the fragrance of flowers
> We find the king enjoying a dance at court.

The male lead dancer and four attendant dancers at the back advance, kneel down and bow. Then they rise and the lead dancer sings the song of praise:

> So beautiful the tunes played on the bamboo flute
> The sound as clear as a bell

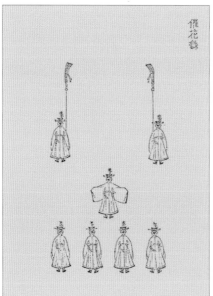
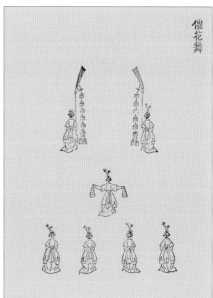

So intimate the petals of rose balsams

Piled one on top of another

As they play the music of the cherry blossom garden

The beautiful woods are filled with festive songs

With songs and dances

For the king's enjoyment.

All the dancers come together and chant lines such as "spring light lingers…," "Clear dawn has scents of peony blossoms…," "Moving the hearts of the people is a propitious sign for all things…," and "The first cutting with a knife, it bears divine traces…" Then the pole bearers enter and sing the closing refrain:

The brilliantly fresh green

Vies in beauty with the picturesque scenery

Fine songs and elegant dance movements

Are offered in a sumptuous banquet

As the music ends we bow and take our leave.

The pole bearers step back while the lead dancer moves forward and sings the song of praise:

In a peaceful reign we look at a sumptuous banquet
As songs come to an end in the gathering
Clouds passing by hover about the scene
Asking for the drum sound to resound through the flowers
[…]

2) Native Korean Court Dance

Twenty-four court dances were created by Crown Prince Hyomyeong in 1829, the 29th year of the reign of King Sunjo. This number includes new creations and modified versions of Chinese dances. Known to have been particularly talented in the arts, Crown Prince Hyomyeong used dance as a means to express the authority of the throne in a time of political confusion. Compared to *tangak jeongjae*, the *hyangak jeongjae* works Crown Prince Hyomyeong created place less emphasis on the procedures and formalities of the dance and more on the beauty of the movements and costumes.

(1) Gainjeonmokdan: Dance of Beautiful Women Picking Peonies

According to the *Encyclopedia of Subject Matter* (*Yuanjian Leihan*), Gainjeonmokdan, one of the ten dances of Song Dynasty China, was created by a scholar-official named Tao Gu under the command of Emperor Taizong during the Song period. In the original format, the performers wore red costumes and a gold-plated headpiece decorated with a phoenix and peony design. Adopting the content and title of the Chinese dance, Crown Prince Hyomyeong created a Korean version, which features ten female dancers surrounding a large vase of peonies

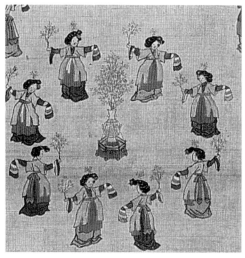
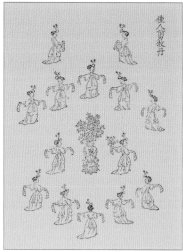

Fig. 48
Dance of Beautiful Women Picking Peonies from a folding screen depicting a royal banquet in 1848

Fig. 49
Dance of Beautiful Women Picking Peonies depicted in the *Royal Protocol of the Banquet of 1829* (*Gichuk jinchan uigwe*)

installed at the center of the stage and picking flowers from the vase.

First the musicians bring a large vase to the center of the stage. As they leave, twelve female dancers enter and form two lines of six behind the vase. The two groups move forward and kneel down to bow. Standing up, they sing the following song:

> Tens of thousands of flowers in full bloom brighten the palace
> So splendid are the red and yellow flowers in their envy
> "Cheongpyeongak" [Music of Perfect Peace] on the jade oboe resonates through the palace
> As butterflies flutter, the fragrance of flowers fills in the air.

The two groups of dancers join to make one big circle and turn so that their backs are toward the vase and then turn around again to face the vase. Then they approach the vase and pluck flowers from it and turn outward, holding flowers in their right hands. They form a big circle, and in pairs face each other and then turn back to back, and then approach the vase again. The dancers form a circle and each dancer turns as she returns to her original position. All the dancers then come forward, bow and exit.

(2) Geomgimu: Sword Dance

Geomgimu, as described earlier, originated from the story of Hwangchangnang, a famous *hwarang* (elite warrior youth) of Silla. As the original dance had not survived, Crown Prince Hyomyeong created a new version. Originally it was performed in diverse formats by two, four, six or eight female court dancers, but only the eight-dancer version performed by the dancers of the Gyobang, an institute for training female entertainers in Jinju, Gyeongsangbuk-do, has survived. The Jinju Sword Dance performed by eight dancers has been designated Important Intangible Cultural Property No. 12 by the government for its preservation.

Two records in *Diagrams and Records of Rituals* compiled in 1901 (the 30th year of the reign of King Gojong) briefly mention this sword dance. The records mention the dance procedures but not in detail.

To the tune of "Muryeongjigok," military processional music, musicians come in and place swords in the middle of the stage. As they leave, four female dancers enter and stand in a line. In two groups of two they face each other with the swords between them. Switching places, the two groups leave and then enter the stage again, switch

Fig. 52, 53
Dance of the Harvest
Painting depicted in the
*Royal Protocol of the
Banquet of 1902* (*Imin
jinyeon uigwe*)

places one more time and return to their original positions. They stand face to face, then turn back to back and kneel down to grab the swords and stand up again. Bending forward and backward, the dancers move in a large circle and then stand in line. Dancing forward and backward they kneel down to bow and then leave the stage.

(3) Gyeongpungdo: Dance of the Harvest Painting

Gyeongpungdo was created by Crown Prince Hyomyeong during the reign of King Sunjo (r. 1800-1834), borrowing the name from a Chinese song written by the founder of China's Song Dynasty.

In this dance the lead dancer first comes forward holding a painting depicting an abundant harvest and presents it to the king while five dancers sing and dance to pray for the harvest. In formation, the lead dancer stands at the front holding the painting, while the five dancers stand in a line behind her. Musicians come and place a table on the stage and leave again. Then the lead dancer comes out holding the painting and stands behind the table and sings:

The name of our great king shines bright across the land

Rich in all the virtues, his repute is well deserved

The great emperor has presented a beautiful omen

An abundant harvest and prosperity for ten thousand years

Auspicious clouds shine in beautiful colors

The sun's blessed energy reveals an omen

The red bird and the black tortoise make heaven's fortune flourish.

The lead dancer places the painting on the table and kneels down and bows. When she rises and moves back to her original position the attendants sing the following song:

Fig. 54
Dance of Goguryeo depicted in the *Royal Protocol of the Banquet of 1828* (*Muja jinjak uigwe*)

A bumper year this year, a bumper year next year

Every year is a bumper year bringing prosperity to all

The immortals uphold the jade box with a harvest painting on one side

Showing heavy grains with nine ears each

Thus we sing praises of the virtue of our king.

(4) Goguryeomu: Dance of Goguryeo

According to *The Complete Classics Collection of Ancient China*, Goguryeomu is based on a poem written by the soldiers guarding the border region of Liadong Province during the reign of Emperor Yang Guang (r. 604-617) of the Sui Dynasty. A dance performed by six boys was created to match the words of the poem during the reign of King Sunjo of Joseon. Some argue that the name of this dance dates to the Goguryeo Kingdom, but the name simply refers to the content of the original poem, which reminisces about the past.

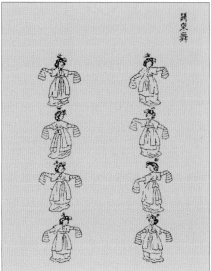

Fig. 55
Dance of No Honor depicted in the *Royal Protocol of the Banquet of 1828 (Muja jinjak uigwe)*

Fig. 56
Dance of Gwandong depicted in the *Royal Protocol of the Banquet of 1848 (Musin jinchan uigwe)*

The six male dancers stand in two columns of three to the left and right, respectively. They bring their hands together, come forward, and kneel down and bow. Then they rise and sing the following song:

Dressed in golden hats

Riding around on white horses

They dance with long sleeves flapping

Like birds arriving at dawn.

(5) Gongmangmu: Dance of No Honor

Xiang Yu of Chu and Liu Bang, Lord of Pei, were rivals who fought to become the first emperor of China's Han Dynasty. One day, when Xiang Yu was about to attack Liu's forces, some of his rivals visited his camp in Hong-men. During the feast that followed, Xiang Yu's advisor, Fan Zeng, plotted to kill Liu. He ordered Xiang Zhuang to perform a sword dance and kill Liu, but when the critical moment came Xiang Bo, an uncle of Yu's, leaped up and protected Liu with his arms (literally "sleeves"). From that time, performing the sword dance was prohibited

in the Chinese court. Instead, a "towel dance" was performed with a long scarf or towel in place of a sword.

In Korea, a dance called Gongmangmu, meaning "please do not dance," was created in 1828 (the 28th year of the reign of King Sunjo) featuring performers wearing a military uniform with a bamboo design and military cap, holding a long sword in each hand. When the music starts the two male dancers face each other. They raise their arms and dance forward and backward, face each other then turn back to back and turn again to face the north. When the music ends a musician enters and leaves the swords in the middle of the stage. The dancers kneel down facing each other and then grab the swords and brandish the shining blades. They rise and circle the stage and then come forward, kneel down and bow. They rise and leave through the southern exit.

(6) Gwandongmu: Dance of Gwandong

This dance was created in 1848 (the 14th year of the reign of King Heonjong) based on a poem by Jeong Cheol (1536-1593) titled "Gwandongbyeolgok" ("Song of the Scenery of Gwandong). In 1580, at the age of 45, Jeong Cheol was appointed governor of Gangwon-do Province and during his term he wrote the poem celebrating the beautiful scenery of the Gwandong region, especially Mt. Geumgangsan and the East Sea. The dance was performed by eight female court dancers who were divided into lines on the east and west sides of the stage. Unfortunately the dance has not survived to the present.

(7) Gwangsumu: Wide-sleeved Dance

A poem written by Liang Jianwen of China describes Gwangsumu as "a dance performed with arms spread out wide, then hanging slightly," while Li Bai also wrote in a poem "the two arms are spread out wide like a bird flapping its wings and flying in from the eastern country [Korea]."

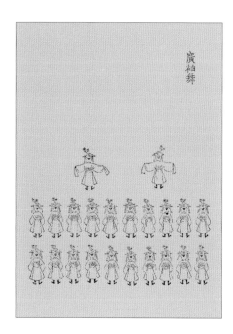

It is not known exactly when this dance was created but records show that it was performed at a palace feast on the 28th day of the 9th month of 1719 during the reign of King Sukjong (r. 1674-1720) and also at a court banquet in the 7th month of 1901. It is performed by two boys facing each other and then turning back to back. The steps are recorded in the *Record of Court Dance by Male Dancers* (*Jeongjae mudong holgi*) from 1901.

To the music of an ensemble of Chinese and Korean instruments the young male dancers stand side by side, facing the north, and come forward to bow. Rising, they spread their arms and then hold the left one up while the right is lowered and then switch arms, holding the right one up and the left one down. When they finish they face each other and dance forward and backward then come forward slightly to kneel down and bow. Then they rise and leave through the southern entrance.

(8) Mansumu: Dance of Longevity and Immortality

Mansumu is mentioned in the *Royal Protocol of the Banquet of 1828* (*Muja jinjak uigwe*) which says, "In the Song and Zhou dynasties of China the music [used] was originally a song to thank heaven, but later it took on aspects of a song for longevity featuring beautiful costumes…" In *The Complete Classics Collection of Ancient China* it is recorded that the first piece of music performed at a feast honoring the king is called "Song of Longevity" ("Mansujigok"). During the reign of King Sunjo a dance was created based on the same song, featuring an immortal offering the king a heavenly peach to wish him longevity and immortality.

In this dance a scroll bearer stands at the front with four dancers

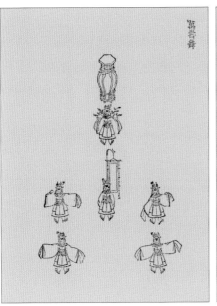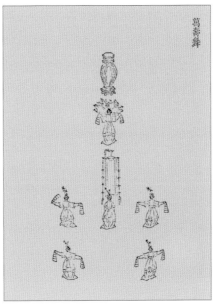

behind, one in each of the four directions, and the lead dancer stands in the middle holding the heavenly peach on a silver platter. Musicians enter carrying a table and place it at the front and leave. The scroll bearer then comes forward and sings the following song:

> The jade screen sways in the gentle breeze from the royal garden
> The king wears his golden robe with the dragon, arms crossed deeply
> The sacred morning light shines on the dazzling palace gate
> Riding down on a holy cloud the immortal descends and holds court
> From the golden palace Yao and Shun lean to the big dipper
> And Emperor Shun's song rings from Ongnugak [pavilion].

After the song the lead dancer and four dancers come and stand at the front. Holding the platter with the heavenly peach, the lead dancer comes forward until she is just behind the table and sings a song of praise:

The legendary peach blooms on the palace stairs

The jade platter is full of the fruit of three thousand years

May the king's life be as long as three thousand springs

As the auspicious sun shines bright red.

After this song the lead dancer places the peach platter on the table, and bows. Next the four dancers come forward and sing:

Ah, ten thousand years

Enjoyment for another ten thousand years

Then add a hundred million years

And to that a million billion years

A deep rooted tree has many branches

Water from a deep spring flows far into the sea

King Mun's grandson has managed 100 years

May Seongjo's grace reach everywhere and flourish forever.

(9) Mangseonmun: Peacock Fan Dance

This dance was created in the Joseon Dynasty during the reign of King Sunjo as a copy of a Tang Dynasty performance of song and dance held to praise the grace of the king. This dance is mentioned in the *Record of Court Dance by Male Dancers* from 1901.

In formation, four dancers holding fans made of peacock feathers stand at the front and two lantern bearers behind. The fan bearers come forward and make two archways. The lantern bearers pass through the archways and face each other, then turn away from each other and then face north. Then the lantern bearer on the left side makes a circle to the left and the one on the right side to the right, returning to the back and passing through the archways again, repeating the same steps. The four fan bearers make a large circle and then stand side by side, each passing through the archways and

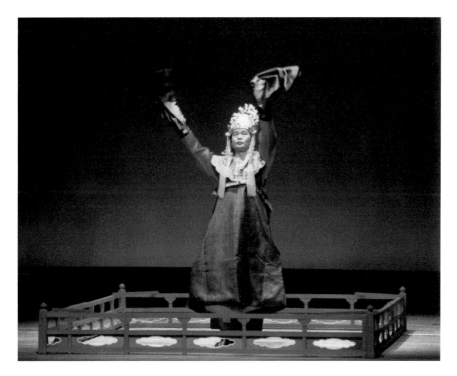

Fig. 60
Dance of the Fragrant
Mountain performed by Lee
Heung-gu, title holder of
Important Intangible
Cultural Property No. 40

returning to their original lines. Then all the dancers move to the back and leave through the southern exit.

(10) Musanhyang: Dance of the Fragrant Mountain

According to the *Royal Protocol of the Court Banquet* of 1828 (*Muja jinjak uigwe*), this dance came from the Tang Dynasty where King Runan wore a silken hat with red flowers in it. In addition, *The Complete Classics Collection of Ancient China* mentions a poem titled "Musanhyang" by Li Taozi, which features a similar silk hat.

This is a solo performance by a young male dancer on a platform similar to a wooden bedstead that is placed in the middle of the stage. Holding his hands together the dancer goes up onto the platform and then kneels down and bows. He then rises and begins to sing:

Of all the people I alone gained the king's favor

I rushed and changed into a perfumed robe of silk

With narrow sleeves

This song I joyfully offer is like the oriole

Chirping in the branches above

With dance movements as light as clouds

Drifting away on the breeze.

After the song the dancer opens his arms out and moves to the back of the platform. He then performs a series of typical court dance moves, including *isugojo* (explained in the introduction). Toward the end of the dance he circles the platform until he reaches the corner and faces north, and then descends. Facing north he brings his hands together, kneels down and bows. He then moves to the back and leaves through the southern exit.

(11) Bakjeopmu: Butterfly Dance

In the *Yuanjian leihan*, an old Chinese encyclopedia, it is recorded that in the Tang Dynasty, on the 15th day of the 2nd month, a festival was held featuring a butterfly dance with two dancers at the front, one each at the left and right, and two at the back. In the Joseon Dynasty it was recreated during the time of King Sunjo to imitate butterflies fluttering around in pairs. The dance featured the following song:

Fluttering two by two colorful butterflies

Dance among the golden flowers two by two

In dresses embroidered with butterflies

The dancing flowers shine radiantly.

(12) Bosangmu: Jewel Throwing Dance

According to the *Royal Protocol of the Court Banquet of 1902 (Jinyeon uigwe imminnyeon)*, "when Tu Luo Wang [of China] went to a monastery in the Kunlun Mountains to practice asceticism, he played the zither and sang the sutras [religious texts], which made Kasyapa and the others hold up their arms and begin to dance." *The Complete Classics Collection of Ancient China* also mentions a dance with turning motions from the Han Dynasty.

During the reign of King Sunjo of Joseon a new dance was created featuring a tray-table with high sides placed in the middle of the stage holding a jar decorated with a lotus design. One dancer stands on the west side while six dancers take turns at throwing a beautifully painted ball into the jar, in a manner similar to the ball-throwing dance Pogurak. If the ball goes in the jar the dancer is rewarded with a flower and if it does not she is punished by having an ink dot painted on her cheeks. To the left of the table stands a person holding the flowers, and to the right a person holding a paintbrush. The dancers stand behind the table, three to the east and three to the west. They all come forward, kneel down and bow. Then they rise and sing together

Fig. 62
Jewel Throwing Dance from a folding screen depicting a royal banquet held in 1901

> The holy sun shines on the brilliant stage with jade curtains
> The place of the bamboos is clothed anew in silken raiment.

Then the six dancers move to the back and return to their positions, and the flower and paintbrush bearers place the colored balls to the left and right of the table and leave. The first dancers on the left and right come forward and kneel down to pick up a ball and sing:

The music of the immortals comes from the pavilion in the clouds of five colors
The colors of the rainbow dance on the railings decorated in jewels.

With the table between them, the dancers hold their hands up and move forward and backward two times and then take turns throwing the ball into the vase. The second pair sings:

Pushing the silken curtains aside the colored sleeves come into clear view
When the jade screen is raised the balls give off their scent.

The third pair come forward and sing:

Don't push us between the flowers with the music of flute and drum
Our only concern is not to fall where the flower petals are.

(13) Saseonmu: Dance of the Four Immortals

In the Silla Kingdom elite young warriors known as *hwarang* roamed the wild, training in letters and the military arts. The four immortals referred to in this dance are four *hwarang* named Yeongnang, Sullang, Ansang, and Namseokhaeng.

When the *hwarang* reached Mt. Geungangsan they stopped to dance, and this is said to be the origin of Saseonmu. Though it is not known exactly what dance movements the *hwarang* performed, in 1829 Crown Prince Hyomyeong created a new version as a way to address the political confusion of the time and express his hopes for an era of peace and prosperity, such as that of the times when the *hwarang* could roam the world to train body and mind.

In formation, two dancers holding lotus flowers stand at the front and behind them stand four female dancers, two on each side. The dancers holding flowers come forward and face each other, then turn back to

Fig. 63
Dance of the Four Immortals from a folding screen depicting a royal banquet held in 1902

Fig. 64
Dance of the Four Immortals depicted in the *Royal Protocol of the Banquet of 1901* (*Sinchuk jinyeon uigwe*)

back and face north. Then the four female dancers hold up their hands and come forward to kneel and bow. Then they rise and sing:

> How wonderful, how grand the eastern country looks today
>
> The immortals of Silla have come back to play
>
> Will they come to Penglai or Yingzhou
>
> Receiving the command of God
>
> They come from China to pray
>
> For the longevity of the illustrious king
>
> The big dipper sparkles in the jade cup of wine.

(14) Seonyurak: Boating Dance

The original Seonyurak from Silla has not been handed down, but a version has been reconstructed on the basis of ancient documents and is performed today. According to the royal protocols for a court banquet in the year 1829 (the 29th year of the reign of King Sunjo), Seonyurak is a dance where a boat is placed in the center of the stage and pulled

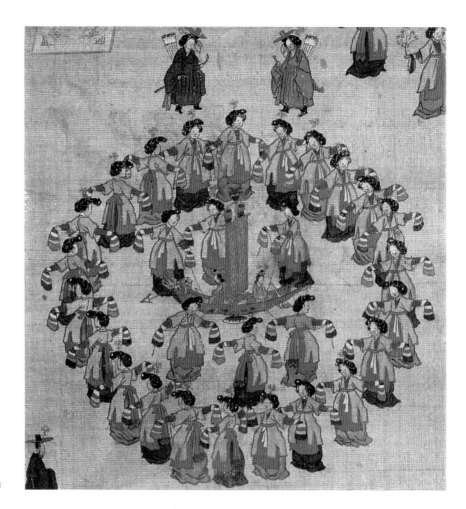

with ropes by female dancers.

Inside the boat are two young girls, sitting back to back. Two officials stand on either side of the boat and the dancers are divided into two groups, ten on the inner side and thirty-two on the outer side, and they all sing the "Song of the Fisherman" ("Eobusa") as they dance. From 1829 to 1901 this dance was performed at various court banquets and celebrations.

(15) Chimhyangchun: Dance of Spring Delight

According to the *Royal Protocol of the Banquet of 1828* (the 28th year

of the reign of King Sunjo), Emperor Xuanzong of the Tang Dynasty planted peonies around Chenxiang pavilion and when the flowers were in full bloom he granted golden flowers to the court musician Li Guinian. To celebrate this event, Li created a dance set to a poem by Li Bai. In the dance two vases are placed at the front, left and right, and a dancer stands behind each one. The dancers hold up their arms and then come forward, kneel down and bow. They rise and sing the following song:

Fig. 66
Dance of Spring Delight depicted in the *Royal Protocol of the Banquet of 1828* (*Muja jinjak uigwe*)

> Oh beautiful girl from the village north of Chimhyangjeong
> Dressed in a red skirt and jade colored jacket
> Though you waft in with the wind and smile, powerless are your airs
> Like Yang Gufei waking from her sleep.

After the song the dancers turn to face each other, then turn back to back, change places and turn around. Then they approach the vases and pluck the flowers out of them, one turning left and one turning right, then both facing north. Next they come forward, kneel down and bow before leaving via the southern exit.

(16) Yeongjimu: Dance of the Lotus Pond

According to the Chinese literary dictionary *Peiwen yunfu*, Emperor Wu Ti of the Han Dynasty saw a beautiful girl reflected in a lotus pond under the moonlight and began to dance. The Chinese book *Yuanshi yetingji* also says the emperor glided over the pond in a boat as he sang, forbidding anyone else from coming near the water. In the boat he recited the following poem:

Fig. 67
Dance of the Lotus Pond depicted in the *Royal Protocol of the Banquet of 1828 (Muja jinjak uigwe)*

The morning sun shines bright and clear
Under the moonlight the water is like a mirror
The figure of a beautiful young girl in the pond beckons me.

This poem was set to a dance in the Joseon Dynasty. Six young male dancers performed on and around a wooden platform representing a lotus pond.

(17) Cheomsumu: Dance of the Pointed Sleeves

According to the *Royal Protocol for the Court Banquet of 1828 (Muja jinjak uigwe)*, in the 28th year of the reign of King Sunjo, a dance called Anjeolmu was performed by dancers wearing costumes with pointed triangular sleeves. This dance was combined with the Sword Dance during the reign of Yeongjo when orders were made to include two dancing boys at the back wearing costumes with pointed sleeves and carrying swords in each hand. They danced face to face, then back to back and turned around. This dance was reserved for "outer banquets," that is, those held for the king and his officials.

(18) Cheopseungmu: Dance of Many Verses

This dance was created during the reign of King Sunjo. Court dances can be divided into those in which song is predominant and those in which dance is predominant. This dance has 10 songs, or verses, and hence belongs to the former category.

In formation, the dancers stand in the four directions, one at the front, another at the back, two in the east, and two in the west. All six dancers come forward to kneel down and bow. They rise and sing the first verse:

Fig. 68
Dance of the Pointed
Sleeves depicted in the
*Royal Protocol of the
Banquet of 1828 (Muja
jinjak uigwe)*

Fig.69
Dance of the Pointed
Sleeves depicted in the
*Royal Protocol of the
Banquet of 1829 (Gichuk
jinchan uigwe)*

Under the spring sunshine the blind is raised in the pavilion
Young sparrows fly down from the picturesque eaves two by two.

They step back to face each other, turn back to back, and turn in a big circle and return to their original places. Then they sing the second verse:

The engraved railings shine with the colors of many flowers
Twelve scents are there in the garden mellowed by spring.

Then the six dancers divide into two groups, north and south, and facing north they sing the next verse:

As spring comes to the people inside the Han royal palace
They move lightly like the wind on the skirts of the celestial maiden.

Then the dancers divide into two groups, east and west. They change

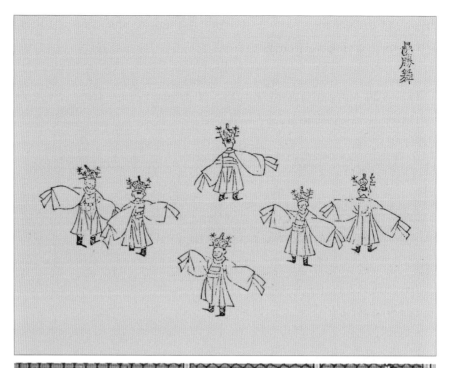

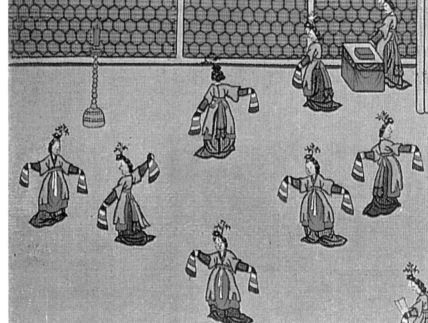

Fig. 70
Dance of Many Verses
depicted in the *Royal
Protocol of the Banquet of
1902* (*Imin jinyeon uigwe*)

Fig. 71
Dance of Many Verses from
a folding screen depicting a
royal banquet held in 1901

places and then change back again. Back in their original positions they face north and sing the fourth verse:

> The spring moon rises slowly over the jade pavilion
> The flowers dance and make shadows before the beautiful skirt of blue.

Next the dancers lift their arms as they move and sing the fifth verse:

> The wall with jade foundations and flower-patterned stones
> Gently, gently they dance along the wooden walkway.

Then all the dancers move forward and backward, and the first dancer on each side comes forward to sing the sixth verse:

> The spring sun shines first on the pavilion surrounded by flowers
> Two by two the court ladies tease the colored balls.

Next, the second dancer on each side comes forward and together they sing the seventh verse:

> The morning sun rises over the palace pond
> The disciples of Liyuan sing the words of a new song.

Next the third dancer on each side comes forward and together they sing the eighth verse:

> The disciples of Liyuan are playing a new song
> With the blind half up at Chimhyangjeon Pavilion.

Then the three dancers on the left face west and the three on the right face east. Together they form one big circle, change places and

Fig. 72
Beginner's Dance depicted in the *Royal Protocol of the Banquet of 1828* (*Muja jinjak uigwe*)

Fig. 73
Beginner's Dance depicted in the *Royal Protocol of the Banquet of 1902* (*Imin jinyeon uigwe*)

turn, then form a line and sing the ninth verse.

> The queen and concubines come to the spring pond
> The fragrance plays anew at the cherry blossom pavilion.

Then all six dancers move forward and backward and return to their original positions. They stand and sing the tenth verse.

> The sound of the drum chases the flowers in the palace garden
> The court lady in the purple robe is plucking the lute.

Then all six dancers come to the front to kneel down and bow. They rise and leave through the southern exit.

(19) Chomu: Beginner's Dance

The *Royal Protocol of the Court Banquet of 1902* (*Iminyeon jinyeon uigwe*) shows that Liu Lian, who taught rites and music to the Zhou China

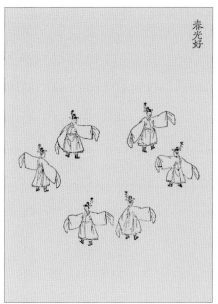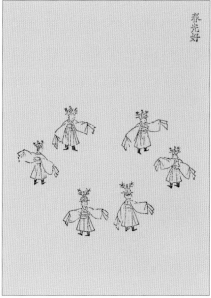

Fig. 74
Dance of the Glorious
Spring Light depicted in the
*Royal Protocol of the
Banquet of 1828 (Muja
jinjak uigwe)*

Fig. 75
Dance of the Glorious
Spring Light depicted in the
*Royal Protocol of the
Banquet of 1902 (Imin
jinyeon uigwe)*

court created a brief dance to teach beginners the basic movements of court dance.

Likewise, Chomu was a dance newly created during the reign of King Sukjong of the Joseon Dynasty to teach young male dancers the basics of court dance. In later times it was performed as a duet at court banquets. A very simple dance consisting mainly of arm movements, it has not been handed down to the present.

(20) Chungwangho: Dance of the Glorious Spring Light

According to the Chinese encyclopedia *Yuanjian leihan*, this dance was created during the reign of Xuanzong of the Tang Dynasty. It is based on an old story about a military song describing peach blossoms and apricot blossoms in full bloom in early spring. The gods looked down at the army, which was teeming with people like a profusion of flowers, and were pleased. By the grace of the gods no soldiers were killed, so everyone returned home. The dance was performed by six males, two each in the south and north and one each in the east and west.

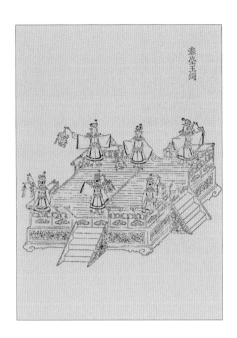

(21) Chundaeokchok: Dance of Ornamental Lanterns

In *The Complete Classics Collection of Ancient China* it is recorded that Emperor Taizong of the Song Dynasty personally composed a song titled "Xiao Shi Tiao" (literally "small stone music"), which mentions a raised platform. The dance called Chundaeokchok, created by Crown Prince Hyomyeong in 1828, features four young male dancers on a raised wooden platform, standing in the four directions and holding lanterns. Three of the dancers come to the front of the platform and one remains at the back. The dancers face each other, turn back to back, and then face north and turn as they dance. Two male dancers holding ceremonial implements stand behind the platform, to the left and right, and face north.

(22) Chunaengjeon: Dance of the Spring Oriole

According to *Jiaofangji*, a treatise on the court entertainment office of China, Emperor Gaozong (651-683) was moved by the song of a bird that was carried to him on the wind one morning. When he asked what kind of bird it was, he was told that it was an oriole. Gaozong then commanded the musician Bai Mingda to compose a piece of music inspired by the bird's song. The composition was titled "Chunaengjeon" (Ch. "Chun ying zhuan") and was later used as accompaniment for dance.

A record of court music lyrics from the Joseon Dynasty states that in 1829 (the 29th year of of the reign of King Sunjo), Crown Prince Hyomyeong created a dance based on records in the *Yuanjian leihan* describing Emperor Gaozong's experience with the song of the oriole. The dance is generally performed by a solo female performer, but today

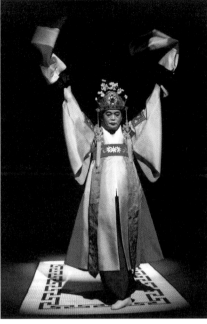

Fig. 77
Dance of the Spring Oriole depicted in the *Royal Protocol of the Banquet of 1848 (Musin jinchan uigwe)*

Fig. 78
Dance of the Spring Oriole performed by Lee Heung-gu, title holder of Intangible Cultural Asset No. 40

it is sometimes performed by a male dancer, on a woven mat, and he sings the following verse:

> Oh, walking under the moonlight
> The wind rustles through silken sleeves
> Proudly beautiful even before the flowers
> To the youth we entrust affairs of the nation.

(23) Hyangnyeongmu: Bell Ringing Dance

In the Joseon Dynasty, Crown Prince Hyomyeong recreated a Tang Dynasty composition called "Faqu," replacing the original cymbals with bells, which were held in both hands and shaken while dancing.

Two dancers stand at the front, one behind the other, and behind them stand two dancers on the west side and two dancers on the east side. They ring their bells to the beat as they sing the following song

and dance, first facing each other, then turning back to back and then facing north:

> Music plays at the Jade Palace
>
> The immortals come to visit
>
> Wearing a phoenix pattern robe and kylin [mythical animal] pattern belt
>
> Leaving perfume behind as they lithely dance
>
> Our only wish is for the king's longevity
>
> May your life be as long as heaven
>
> The spring breeze blows on the flowers in the yard
>
> Which last for tens of thousands of years.

(24) Heoncheonhwa: Offering the Heavenly Flower Dance

According to the *Royal Protocol of the Court Banquet of 1902*, Heoncheonhwa is a dance that celebrates the descent of a celestial maiden from heaven carrying a flower which she presents to the king.

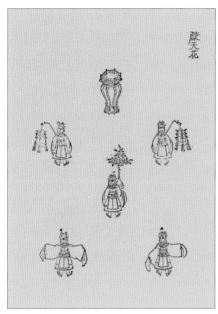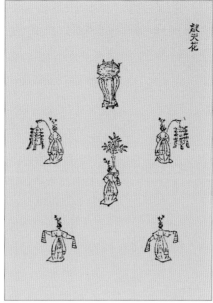

It is recorded in *The Complete Classics Collection of Ancient China* that this dance originated in Song Dynasty China, and featured 18 children offering incense and flowers to a bodhisattva. The dance was recreated in 1828 by Crown Prince Hyomyeong as a celebratory performance featuring the lead dancer presenting a heavenly flower to the king.

A stand is placed at the front. Two male dancers, holding lanterns, stand behind it, to the left and right. Another dancer, holding a vase, is behind the stand and behind him are the attendant dancers, one on each side. The two boys holding lanterns come slightly forward, followed by the lead dancer and the two attendants, who kneel down and bow. Then they rise and sing:

Auspicious clouds surround the golden palace

The jade vase holds flowers from heaven

Before the cut flowers the king listens to music divine

And the courtiers in hats and jade pendants cluster like stars.

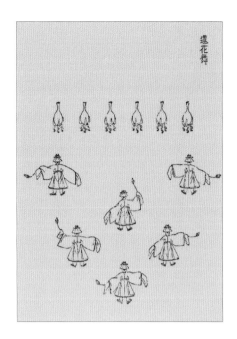

Fig. 83

Lotus Dance depicted in
the *Royal Protocol of the
Banquet of 1828* (*Muja
jinjak uigwe*)

(25) Hangjangmu: Sword Dance of Xiang Zhuang

As in Gongmangmu, or the Dance of No Honor (see previous description), this dance is based on the story of Xiang Zhuang's (Hangjang in Korean pronunciation) attempt to kill Liu Bang, a contender for the throne, while performing the Sword Dance. This tale was incorporated into the entertainment of commoners in the Seoncheon region of Korea (today's Pyeonganbuk-do Province in North Korea), and in 1873 during the Joseon Dynasty it was introduced to the royal palace where it developed into a form of native court dance.

(26) Sajamu: Lion's Dance

Choi Chi-won's *Five Poems on Native Korean Music* (*Hyangak jabyeong osu*) describes five entertainments. One of them is *sanye*, which refers to a lion dance originating in the regions west of China. Master Ureuk's "Twelve Musical Compositions" from the Silla period also mentions *sajagi*, which means "lion play."

From these records it is surmised that the Lion's Dance originated in countries west of China and entered Korea during the Three Kingdoms period. During the reign of King Gojong (r. 1863-1907) of the Joseon Dynasty a form of lion's dance featuring a blue lion and a yellow lion was performed at annual court rites.

(27) Yeonhwamu: Lotus Dance

According to *The Complete Classics Collection of Ancient China*, a dance called *zhezhi*, which means "lotus dance," was performed in China by two female dancers wearing beautiful robes and hats with bells attached that rang when the dancers turned. This dance was the basis for the

previously described lotus dance, Yeonhwadaemu, which was then revised by Crown Prince Hyomyeong of Joseon in 1829 and renamed Yeonhwamu.

INDEX OF DANCE NAMES

REFERENCES

Expanded Reference Compilation of Korean Documents (Jeungbo munheon bigo), Joseon Dynasty

Royal Protocol of the Banquet of 1719 (Gihae jinyeon uigwe), 1719 (45th year of the reign of King Sukjong)

Royal Protocol of the Banquet of 1828 (Muja jinjak uigwe), 1828 (28th year of the reign of King Sunjo)

Royal Protocol of the Banquet of 1829 (Gichuk jinchan uigwe), 1829 (29th year of the reign of King Sunjo)

Royal Protocol of the Banquet of 1744 (Gapja jinyeon uigwe), 1744 (20th year of the reign of King Yeongjo)

Royal Protocol of the Banquet of 1848 (Musin jinchan uigwe), 1848 (14th year of the reign of King Heonjong)

Royal Protocol of the Banquet of 1868 (Mujin jinchan uigwe), 1868 (5th year of the reign of King Gojong)

Royal Protocol of the Banquet of 1873 (Gyeyu jinjak uigwe), 1873 (10th year of the reign of King Gojong)

Royal Protocol of the Banquet of 1877 (Jeongchuk jinchan uigwe), 1877 (14th year of the reign of King Gojong)

Royal Protocol of the Banquet of 1892 (Imjin jinchan uigwe), 1892 (29th year of the reign of King Gojong)

Royal Protocol of the Banquet of 1901 (Sinchuk jinyeon uigwe), 1901 (38th year of the reign of King Gojong)

Royal Protocol of the Banquet of 1902 (Imin jinyeon uigwe), 1902 (39th year

of the reign of King Gojong)

Yuan jian lei han, Tang Dynasty encyclopedia

Yuefu shiji, Tang Dynasty poetry anthology compiled by Guo Maoqian

Association of Goguryeo Balhae, *Goguryeo Tomb Murals* (*Goguryeo gobun byeokhwa*), Hakyoun Munhwasa

Lee Heung-gu and Son Gyeong-sun, *Korean Court Dance* (*Joseon gungjung muyong*), Youlhwadang

Lee Heung-gu and Son Gyeong-un, *Korean Court Dance, Translation of Musical Canon of Joseon from Chinese Characters to Hangeul* (*Joseon gungjung muyong, Akhak gwebeom gukyeok*), Eunha Publishing Co

Jang Sa-hun, *Study of Traditional Korean Dance* (*Hanguk jeontong muyong yeongu*), Iljisa Publishing Co.

Plates: Sources
Folding screen depicting a royal banquet held in 1848 (Musin jinchan dobyeong), Jeonju National Museum: Figs. 7, 13, 33, 48, 65, 80
Folding screen depicting a royal banquet held in 1901 (Sinchuk jinyeon dobyeong), Yonsei University Museum: Figs, 6, 10, 14, 17, 21, 45, 62, 71
Folding screen depicting a royal banquet held in 1902 (Imin jinyeon dobyeong), National Gugak Center: Figs. 40, 63, 79
All royal protocol (*uigwe*) illustrations: Kyujanggak Institute of Korean Studies at Seoul National University